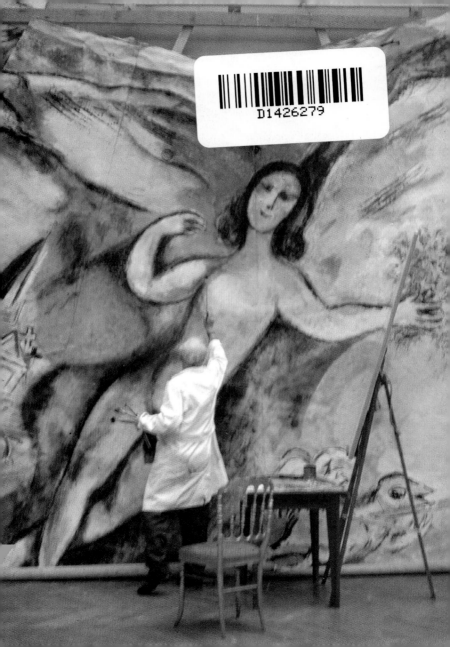

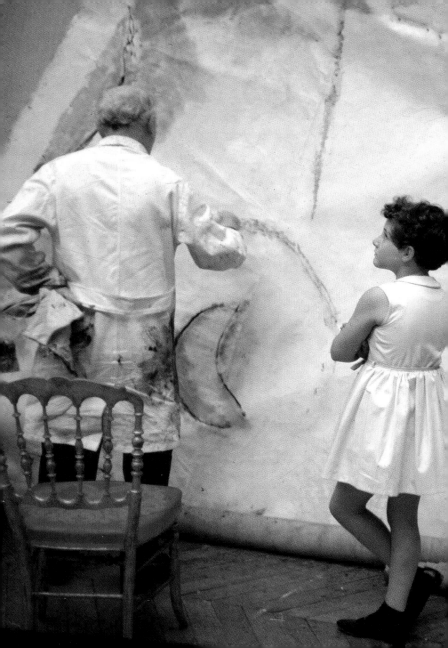

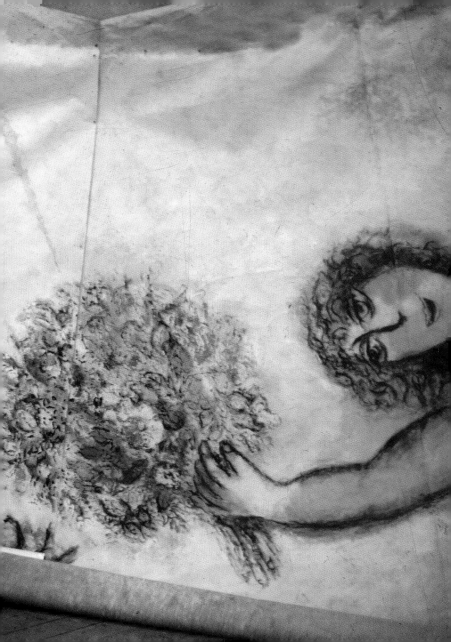

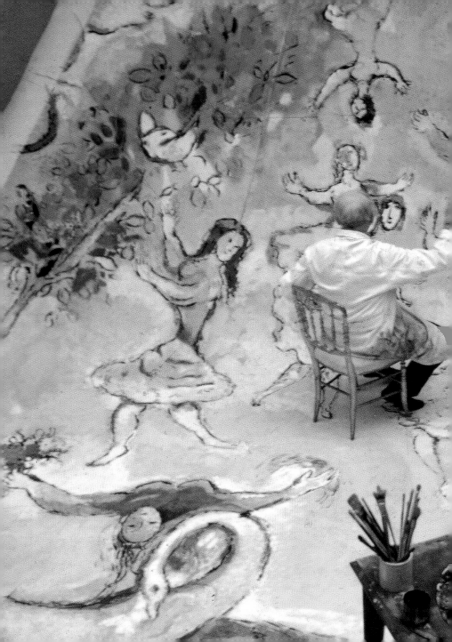

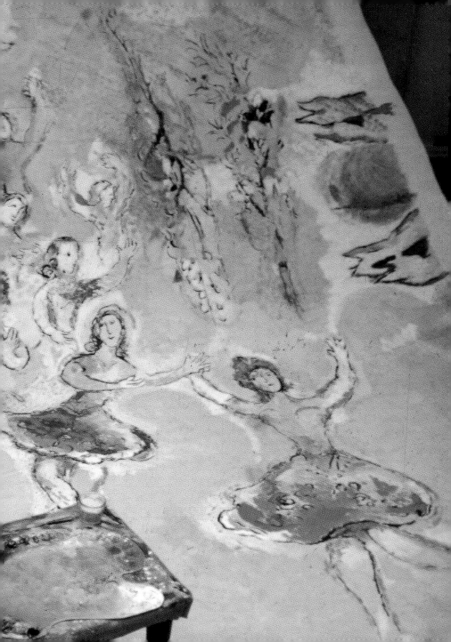

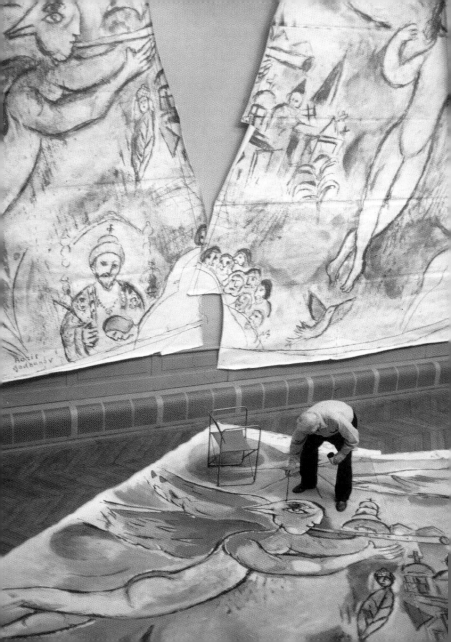

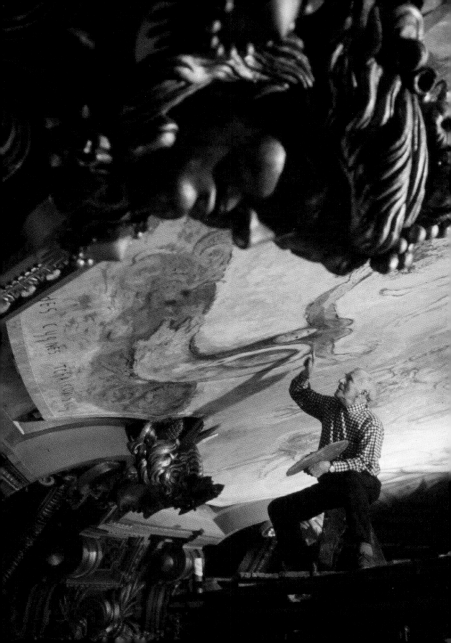

CONTENTS

CHAGALL
THE ART OF DREAMS

Daniel Marchesseau

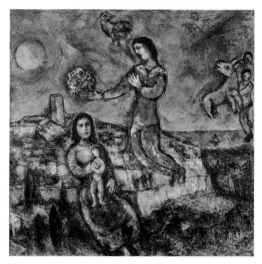

THAMES AND HUDSON

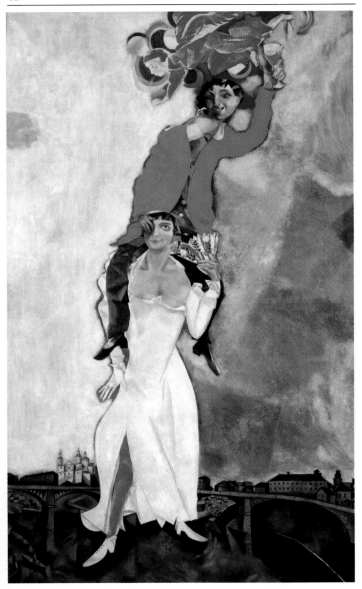

On 7 July 1887 Moyshe Segal was born at Vitebsk in Belorussia, not far from the Lithuanian border, to a Yiddish-speaking family of Hassidic Jews. Zakhar, his father, was a clerk at a herring store, while his mother, Feiga-Ita, ran a small grocery shop. Marc Chagall took a big step in leaving behind the *shtetl* – the Jewish settlement whose traditions went back for years – and in creating his imaginary world.

CHAPTER 1

LEAVE VITEBSK?

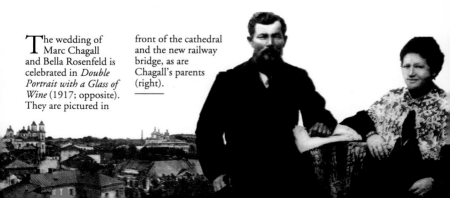

The wedding of Marc Chagall and Bella Rosenfeld is celebrated in *Double Portrait with a Glass of Wine* (1917; opposite). They are pictured in front of the cathedral and the new railway bridge, as are Chagall's parents (right).

Life in Vitebsk, which had been invaded by Napoleon in 1812, was cold and harsh. At the turn of the century, it was home to one of the largest Jewish communities in Tsarist Russia, accounting for almost half of its fifty thousand inhabitants. Throughout Chagall's life, Vitebsk remained the cherished image of his childhood. Chagall continued to evoke the memory of the onion-shaped domes of the churches in the cold northern light right up to the very last works he painted.

The oldest of nine children, Chagall used the members of his family as models for many years. They formed part of his inner world and therefore played a role in the universe he painted. In his autobiography *My Life* of 1922, he described, not without a touch of humour, the poor yet loving childhood that constituted the fabric of his painting. Indeed, he dedicated the book 'to my parents, to my wife, to my native town'.

Chagall's parents lived in this house, which now bears a plaque commemorating the artist, on Pokrowskaya Street, on the right bank of the Dvina (above). It contained the basic comforts: a table, a few chairs, a cradle, a clock, a mirror…. For many years, the members of his numerous family (pictured below around 1910) served as his models: Marc (standing to the left in the back row) is surrounded by his father and mother, his brother David, his sisters, including the twins Lisa and Mania, and Uncle Neuch, a cattle dealer.

Growing up in the Jewish tradition

Little 'Moshka' was born into a poor Jewish neighbourhood, close to Pestkowatik Street and behind a prison and a lunatic asylum. The birth was difficult and, while the baby was taking its time to come into the world, a great fire broke out in the vicinity and the infant was placed in a trough: 'The first thing that caught my eye was a trough. Simple, square, half hollow, half oval, a market trough. Once inside, I filled it completely.' So begins *My Life*.

His grandfather was a tutor and cantor at the synagogue; his father, an ordinary working man, who was brusque and taciturn. Chagall often depicted him as the archetypal pious Jew, dressed in a priestly robe beneath his prayer shawl (tallith), wearing tefillim, his left arm bound by the cords of his phylactery, rocking back and forth in time to the rhythm of the chants.

Chagall's mother, Feiga-Ita (far left), ran the household with great energy. To earn a few kopecks, this prematurely aged but dignified woman kept a small shop, often described by Chagall: 'Herrings in barrels, oats, sugar heaped like pointed heads, flour, candles in blue wrapping – all are on sale. The money clinks. Mujiks, tradesmen and men of God whisper, stink.' Zakhar, his father (left), went to synagogue every morning, as tradition dictated (below, *Study at the Synagogue*, 1918). 'Have you ever seen one of those men in Florentine paintings with an untrimmed beard, eyes that are both brown and ash-grey, and a complexion of burnt-ochre furrowed with lines and wrinkles? That is my father…. But his face, now yellow, now clear, would sometimes break into a wan smile.' (Marc Chagall, *My Life*)

During those poverty-stricken times, the women worked hard. His mother – a capable woman – was the daughter of a ritual butcher from the village of Lyozno. Chagall remained eternally grateful to her for having accepted, if not encouraged, his artistic calling: 'Yes, my boy, I see; you have talent…. Where do you get that talent?' Thirty years later, in *My Life*, Chagall replied to her question, boasting of an illustrious ancestor, Chaim Ben Isaac Segal, who had apparently decorated one of the Ukraine's most beautiful synagogues, in Mohilev, with frescoes a century earlier.

Discovering a vocation

In 1895, when Chagall was eight years old, a new pogrom broke out in Russia. A dreamer and clearly talented in many fields, Chagall wanted to become a singer, dancer, musician, poet… and painter, all at once. All the friends of the family, the domestic chores, the neighbourhood were later used as models in his painting: his world was made up of the butcher, the policeman, the pedlars, the barber-shop, the grocery store, the bank and animals.

The whole family devotedly followed the laws of Hassidic piety, based on love

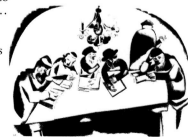

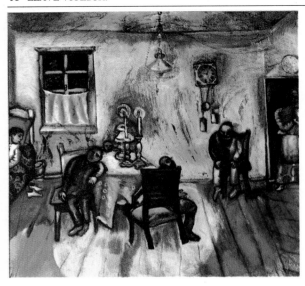

In the main room of the family home, the Sabbath was devotedly observed around the table lit by oil lamps. Time passed slowly, to the rhythm of the prayers recited before dinner, as the clock shows. This canvas (*Sabbath*, 1910) reflects the painter's experimentation during his formative years: vivid colours, familiar scenes and humble subject matter are characteristic of his initial apprenticeship with Pen, who painted the portrait of his most talented pupil as a proud young man (below), breaking with Jewish tradition by not wearing a beard. In 1919 Chagall, then director of the Free Academy of Vitebsk, showed his loyalty to Pen by appointing him to run a studio and he never failed to include his works in group exhibitions.

for one's neighbour. Each celebration was observed: Sabbath, Purim, Succoth, Yom Kippur. Young Marc, whose parents were illiterate, initially attended *cheder*, the traditional Jewish primary school, where he learnt Hebrew and Biblical history. In Tsarist Russia, Jewish children were banned from attending state school, but thanks to a bribe paid by his mother, at thirteen Marc was able to start secondary school, where he learnt Russian and geometry. It was from this time that his dual Yiddish and Russian idiom originates, later to be enriched by French, with an inimitable vocabulary and accent that emphasized a slight stammer.

First initiation

In 1906, at the age of nineteen, Chagall attended the studio that the painter Yehuda Pen had opened in his house, right in the centre of Vitebsk, for two months. The latter, who also spoke Russian badly, had earned a reputation as an academic painter of landscapes and portraits. This brief apprenticeship left a deep impression on the young painter; his portraits of Jews going about their religious tasks recall those of Pen,

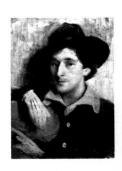

such as *The Reading of the Torah, Interpreting the Talmud, Old Man with Skullcap....* The relationship between master and pupil lasted a short time, but began again during the war: in 1917 each painted the portrait of the other. Even at this stage, in 1906, Chagall stood out for his unrestrained use of colour and fundamental rejection of realism: 'At Pen's, I was the only one to paint in purple. That seemed so bold that from then onwards I attended the school without paying.' As one of the poorest of the poor, Chagall's father was unable to pay any fees and only grudgingly accepted the vocation of his son. To earn a few kopecks, Chagall had to work for a photographer, retouching negatives and prints. In 1907, with only twenty-seven roubles in his pocket, he finally set out for St Petersburg, the capital of all the Russias. The anti-Jewish decrees were rigorously applied on the banks of the Neva: only artisans in possession of a special permit were allowed to reside there.

In 1907, the year in which he painted this *Self-Portrait* (above), Chagall, a poor, provincial and ill-educated Jew, discovered the magnificence of St Petersburg. Below: the Nevsky Prospekt.

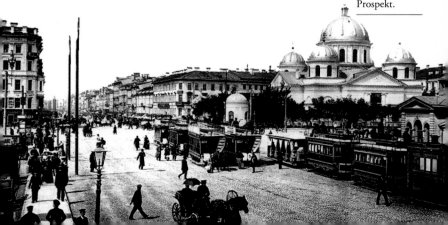

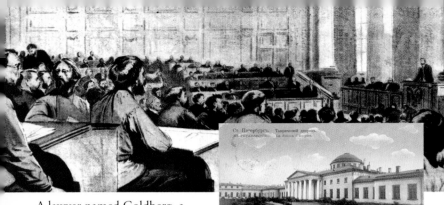

A lawyer named Goldberg, a patron of the arts, officially hired Chagall as a domestic servant so that he could remain within the city walls and enrol at the School of the Imperial Society for the Protection of the Fine Arts. One evening, however, having failed to renew his residence permit, Chagall was beaten and then thrown into prison for a fortnight.

Moyshe Segal in St Petersburg

The young man was delighted to discover the Alexander III Museum and icons by Roublev, 'our Cimabue', as he was to describe him.

Only twenty, he received great encouragement from the young director of the school, Nicholai Roerich, who in April 1907 managed to obtain for him a postponement of his military service, then an exemption, as well as a grant of fifteen roubles a month, from September 1907 to July 1908.

The young student gained a first distinction and lived for a while in a private academy run by Saidenberg, a painter of popular scenes in the style of the 'School of Wanderers'. Poor, unsophisticated and ill-educated, Chagall lived very frugally. More often than not, he shared his straw mattress in a corner of the room with other poor wretches. In his paintings, as in his autobiography, the lamp and the chair remained fundamental archetypes: 'More than once, I watched the lamp burning on the table with envy. "Look how comfortably it burns away there on the table in the room, I thought. It drinks as much oil as it likes, and look at me!"'

The Duma (top and above), the Russian parliament, met in a palace near the Neva. Here Vinaver defended the rights of the Jews forced to reside in certain regions. On Vinaver's advice Chagall (below, around 1908) enrolled in Bakst's classes, where he painted the *Self-Portrait with Brushes* (1909; opposite).

Maxime Vinaver, an extremely influential democratic member of the Duma, the lower house of the legislative assembly established after the 1905 revolution, played a leading role in the Hebrew Historic and Ethnographic Society of St Petersburg. He became Chagall's mentor and housed him in the offices of *Voshod* ('The Dawn'), the Jewish political journal he edited. Shortly afterwards, the painter Léon Bakst, head of the Zvantseva school, accepted him as a student. Founded by Yelizaveta Zvantseva and renowned for its openness to modernity, this school included among its pupils Countess Tolstoy and the ballet dancer Nijinsky. As Chagall recalled, it was Bakst who really made him aware of the 'breath of Europe', encouraging him to leave Russia for Paris. It was from this period that Chagall started to stand apart from Russian artistic circles, already displaying an independent vision and a loneliness – not without a touch of pride – in his total rejection of any artistic community or group.

For a Russian modernity

Chagall studied at the Zvantseva school for two years. In the spring of 1909, when Léon Bakst and the painter and critic Alexandre Benois, founders of the Post-Symbolist group *Mir Iskousstva* ('World of Art') left to rejoin Serge Diaghilev in Paris, Chagall attended the courses given by a more innovative artist: Mstislav Dobuzhinsky, who was the first to introduce him to the work of Van Gogh and Cézanne.

In spring 1910, in the premises of the avant-garde journal *Apollon*, Chagall exhibited for the first time and

●Chagall is my favourite pupil and I adore him because, after having carefully listened to my lesson, he takes his crayons and brushes and does something completely different, an indication of a complete personality and a temperament such as I have rarely come across.❜

Léon Bakst (below)

took part in his first demonstration, supporting a new art that was anathema to the conservative painter Ilya Repin, whose academicism was the rule of the day.

Such courage was fed on the spirit of the times and, with hindsight, can be seen as part of a common European movement. Following the political upheavals of 1905 in Russia, artists rebelling against academicism had regrouped to form the avant-garde, stimulated by Russia's openness to innovation, particularly from France. Journals made an enormous contribution, publicizing major artistic demonstrations, while also organizing exhibitions in which Russian and French painters were compared. Chagall and his contemporaries were thus able to familiarize themselves with the latest dazzling developments in European art from the Fauves – Matisse, Derain and Vlaminck – and the German Expressionists, right up to the Italian Futurist artists.

In 1907 in St Petersburg, the Burliuk brothers, together with the poet Mayakovsky, had founded the first Russian Futurist group prior to taking part, alongside other rebels such as Larionov, Goncharova, Malevich and Tatlin, in the 'Union of Youth', established in 1909. In that year, Larionov and Goncharova opened the second 'Golden Fleece' show in Moscow at the same time as that of 'Free Aesthetic'. Chagall, a witness and player in the neo-Primitivist fervour gripping St Petersburg, continued to send works to Russian avant-garde exhibitions, including the 'Donkey's Tail', organized by his first painting companions, even after he left for Paris.

The different stages in his development, from a powerful Russianized Fauvism to the 'Cubo-Futurism' of the Burliuk brothers, characterized the convergence of opinions in a feverish and euphoric atmosphere from which it was impossible to escape.

'Thou shalt not make thee any graven image, or any likeness of any thing that is in heaven above, or that is in the earth beneath, or that is in the waters beneath the earth' (Deuteronomy 5: 8)

Chagall renounced Hebrew iconoclasm, the Jewish custom forbidding any formal

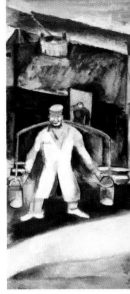

In 1909 Marc Chagall fell in love with Bella Rosenfeld (below). In Moscow, where she completed her studies, she developed a passion for the theatre. Captivated by this spirited young man, she married him in 1915. For the next thirty years, she was to be his loving and adored muse.

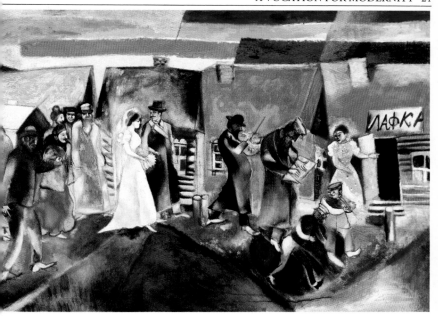

representation of living things, very early on. He became a storyteller and painter of popular images, one who gave formal expression to the memory of Judaism and the message of the Bible, until then prisoner of the Word. His work merges reality and myth, dreams and allegories, metaphorical themes, which were always ambivalent and, in short, frustrated, the real and the irrational, the visible and the invisible, folklore and myth in an entirely modern way.

He developed a new pictorial language, transcending the cultural and ritual world of his origins, to widen the scope of painting.

In the course of time, Chagall, a Jew by birth, became religious in the broadest sense of the word, rejecting all forms of dogma and embracing, in an abstract Judeo-

The Wedding (1910–1; above) was one of the first works painted in Paris, in a series evoking life in Vitebsk, which Chagall explored in several different versions. An ambitious work in terms of both colour and composition, it conjures up a traditional marriage. The mere sight of a water-carrier (on the left) brought good luck. Musicians and a clown, who keep the family entertained during the celebrations, head the procession before the religious ceremony.

Dead Man (1908; left) is one of the three paintings Chagall exhibited with other work by students at the Zvantseva school. This allegorical composition, typical of his early sombre style, was preceded by several

Christian faith, a divine and merciful universal eternity.

The earliest oil paintings (1907–9) show the unquestionable progress he had made in his technique: *The Dead Man*, *Village Fair*, *The Holy Family*, *The Wedding*, *Birth*, evocations of familiar scenes, are also metaphorical compositions, highly emotional and spiritual in content. They stand out for the muted tones of suffering that can be perceived in them, closer to the traditions of the East rather than the West. The architectural framework, with its distorted perspective, is similar to Naive – or neo-Primitivist – painting, while the popular expressionism of the deliberately out-of-scale figures creates a solemn and dreamlike lyricism, unknown in the work of his contemporaries.

Although his stroke still lacks brilliance, the technique, careful and considered, is remarkably confident. For the most part the palette was sombre, but it was also heightened by unusual flat areas painted in almost milky white. The composition shows a rare maturity in its arrangement of spatial planes and in the use of the perspective purposely fragmented at unexpected angles. The taste of the period is reflected in the careful observation and a certain preference for detail, particularly in the fabrics.

studies that establish the diagonal orientation of the perspective. The painter creates a scene which appears religious (though it actually owes nothing to either Jewish or Christian tradition) and which, judging by the humble wooden huts, is set in Vitebsk: a corpse lies stretched out, surrounded by candles, while a woman cries in grief. The sweeper symbolizes indifference and the passage of time. Poised between heaven and earth, a violinist on a roof represents the ritual of mourning through his silent melody. His incongruous position in front of a bootmaker's sign forms part of Chagall's imaginary world, in which illusion and reality are merged.

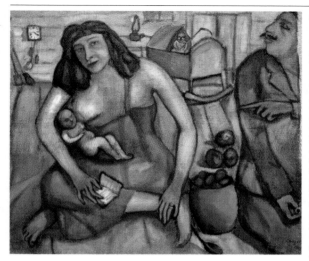

The Holy Family (1909; left) is both a homage to maternity and a fresh Judeo-Christian version of this mythical theme. Painted on linen, it portrays a familiar scene in a static arrangement inspired by popular Russian imagery. The figures are depicted in monochrome, with an awkward tenderness emphasized by the pointed finger of the father. On arriving in Paris, Chagall was inspired by the manifesto *Du cubisme* (*On Cubism*) by Gleizes and Metzinger (below) to develop his writing on the fringes of modernism.

'Vitebsk, I am leaving you…'

In August 1910 Maxime Vinaver, who had been Chagall's patron for several months, offered him a small allowance, which Vinaver continued to give until 1914. Chagall was thus able to leave Russia for Paris. This first journey marked a turning-point in his life, as he decided to settle in the French capital. However, fate was to decide differently.…

As soon as he arrived in France, Moyshe Segal adopted a French name, Marc Chagall. He initially took the studio of a painter, Ehrenburg, at 18 Impasse du Maine, in the neighbourhood of Montparnasse. As was the custom, he frequented several academies, including those known as the Grande Chaumière and La Palette, where Le Fauconnier, Gleizes, Metzinger and Dunoyer de Segonzac taught. Owing to lack of money, he painted on canvases improvised from curtains, and even his own shirts. In *The Violinist* an embroidered motif is visible under a layer of paint.

Rather than attend his classes, Chagall preferred to visit the Louvre, where he had the opportunity to study the old masters, including the Italian and Flemish primitives as well as the great French classical painters.

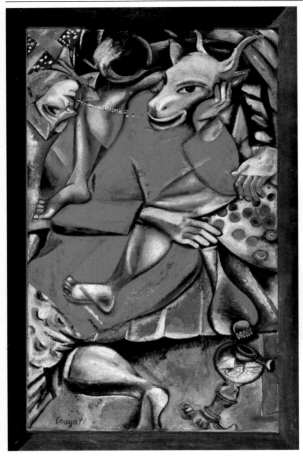

His desire to create art filled with colour grew out of this experience. Not only Delacroix, Géricault, Courbet but also Le Nain, Watteau, Uccello, Fouquet and Chardin made a strong impression on him.

It was a lonely period for Chagall, who felt uprooted and full of self-doubt. Preferring to work at night, he visited by day salons and galleries, including Bernheim, Durand-Ruel, Ambroise Vollard, where he took note

Delaunay (below) had to insist that Chagall be allowed to exhibit *Dedicated to My Fiancée* (left), which Chagall had painted at La Ruche, at the Salon des Indépendants. The title of the work came from Cendrars, who saw in this strange composition, in which the severed head of a woman spits in a monster's face, an evocation of his fiancée Hélène, who had died in

a fire started by an oil lamp. Initially the painting, which for Apollinaire represented 'a donkey smoking opium', had been rejected, but it was touched up to cover the offending detail. The meaning of the work is nevertheless open to conjecture.

At La Ruche, Chagall met Apollinaire and sketched his caricature (opposite, above right) on a tablecloth at a bistrot.

of the investigations into light and space carried out by the Impressionists, Redon, Cézanne, Gauguin and his own contemporaries. He became a dazzling colourist, assimilating with astonishing speed the Fauves' sense of modernity. Bakst paid him a great compliment: 'Now your colours sing.' From Cubism he borrowed the fragmented structure, though he was suspicious of its highly realist technique.

Cendrars, Apollinaire and the others

From 1911 the man his neighbours nicknamed 'the poet' lived in a studio at La Ruche (The Beehive), a run-down group of studios used by impoverished artists, such as Fernand Léger and Henri Laurens, and Chagall's compatriots, Alexander Archipenko, Chaïm Soutine, Ossip Zadkine, as well as writers – André Salmon, Max Jacob – who were to become defenders of the School of Paris.

It was here that Chagall met a Swiss poet of his own age, a passionate and free spirit, who had lived in St Petersburg and understood Russian:

Blaise Cendrars. Their friendship blossomed during Chagall's first stay in Paris. Cendrars, 'light and resonant flame', his accomplice through good times and bad, became his mentor at the very heart of the intelligentsia and introduced him, among others, to Robert Delaunay and his Russian wife, Sonia Terk.

Cendrars was responsible for composing the titles of Chagall's paintings: *Dedicated to My Fiancée*; *To Russia, Donkeys and Others*; *The Poet – Half Past Three*.... He dedicated two of his *Poèmes élastiques* (Elastic Poems) to him and proclaimed in *La Prose du Transsibérien*

Rebuilt near the Vaugirard slaughterhouses after the Universal Exhibition in 1889, La Ruche (above) consisted of a central twelve-sided hall with a rotonda in the shape of a Chinese hat. The studios were grouped in trapezoidal cells, giving it its name ('Beehive').

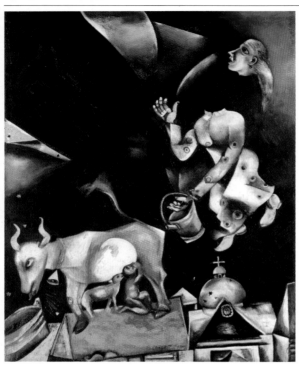

To Russia, Donkeys and Others (1911–2; left) owes its title to Blaise Cendrars (below). Painted in Paris, this allegorical evocation is a complex mosaic of imaginary themes, the *shtetl* and the Judeo-Christian town under a star-filled sky. The woman, whose head is severed as in *Dedicated to My Fiancée* and *Anywhere out of this World*, may symbolize the flight of the spirit from earth to heaven.

(The Prose of the Trans-Siberia): 'Like my friend Chagall, I could do a series of insane pictures.'

In 1912 Cendrars also introduced him to Guillaume Apollinaire: 'That gentle Zeus. He blazed a trail for us in verse, numbers, and flowing syllables.' His visit to the studio should go down in history: 'He carried his stomach like a volume of collected works and his legs gesticulated like arms.... Apollinaire sits down. He reddens, puffs out, smiles and murmurs: "Supernatural!..."', discerning the painter's highly ambiguous attitude to the 'real'. The word also hints at the powerful and eclectic repertoire of images that sprang from the unconscious like a dream. Chagall dedicated to the poet – as well as to Cendrars, Canudo and Walden – *Adam and Eve*, a symbolic homage

unique in his oeuvre and a token of gratitude to his four most fervent supporters.

When Apollinaire received his portrait in purple ink, he dedicated to Chagall a poem, *Rotsoge* ('the freest poem of this century', as André Breton described it), scribbled on the back of a menu. Unfortunately, Apollinaire never wrote the introduction he had promised for the exhibition Herwarth Walden put on in Berlin in 1914.

'Paris, city of the unique Tower, of the great Gallows and of the Wheel' (Cendrars)

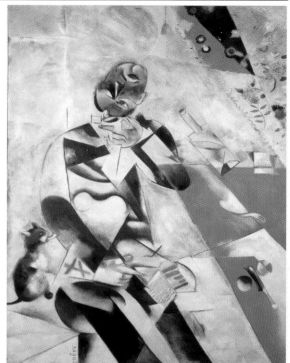

Chagall drew inspiration from Cubism, which he came across in Montparnasse. The title of this painting (above) *The Poet – Half Past Three*, borrowed from Cendrars, recalls the fact that Chagall completed this second version of the *Poet Mazin* at three in the morning, but also that he himself wrote poetry.

Between 1910 and 1914 Montparnasse was full of artists, poets and Bohemians who were all redefining the conception of art in their own individual ways. The work of previously marginalized painters such as Cézanne, Gauguin and Van Gogh, the violent colours of late Fauvism, the radical thought of the Cubists, the explosion of the Futurist manifestos, the birth of Orphism were all crucial events to an artist like Chagall, who had a strong visual sense and was keen to find a means of expression for his ideas. For a time he experimented, briefly but confidently, with Cubist deconstruction and its corollary, chromatic fragmentation in works such as *Adam and Eve*, then *Golgotha* or *Calvary* (1912).

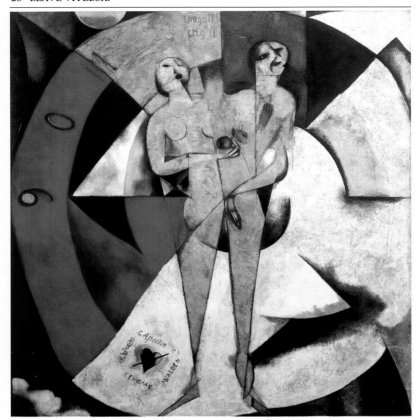

Golgotha, the first significant canvas of his Judeo-Christian inspiration, is an initiatory transcendent confession. It also reveals Chagall's link through colour with his German Expressionist contemporaries and with Paul Klee.

Significantly, the work, the first to be accepted at the Salon d'Automne in 1912, at the insistence of Delaunay and Le Fauconnier, was exhibited, with *To Russia, Donkeys and Others* and *Dedicated to My Fiancée*, at the first German Autumn Salon in Berlin, held at Der Sturm Gallery in September 1913. There

In May 1914 *Homage to Apollinaire* (1911–2; above), dedicated to Cendrars, Canudo, Apollinaire and Walden, was the highlight of his exhibition in Berlin. The esoteric treatment of the hermaphrodite couple in a ring of coloured circles shows Delaunay's influence.

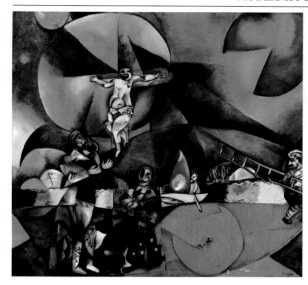

Left: *Golgotha* or *Calvary* (1912), a Judeo-Christian crucifixion, was inspired by Russo-Byzantine icons. The martyr, portrayed with the features of a child, a saviour crowned with a halo made by the sun, embodies the mercy and Jewishness of Christ. In the centre, Charon, the boatman, is waiting in his vessel. On the right, a figure (Judas?) is seen running away with a ladder. The flat areas of colour derive from Delaunay's Orphism.

Below: Chagall (on the left) in Paris in 1911.

it was bought by the Berlin collector Bernard Köhler, patron of Der Blaue Reiter.

Like Delaunay, Marcoussis, Gleizes, La Fresnaye, Metzinger or Lhote, Chagall was also tackling modernist themes: *The Eiffel Tower* – that 'obelisk of iron' – *The Big Wheel, Paris Through My Window*. The French capital embodied for the Russian 'the astonishing freedom–light, the colour–love'. In a fertile socio-political context, two themes occurred again and again: animals (cows, bulls, goats...) and figures with heads reversed or detached from their torsos. From these Chagall drew inspiration to create fresh and lyrical works.

However, Chagall always retained an independent vision, refusing to join any group of artists with a particular method or theory. He remained fiercely loyal to his own memories and to his Russian and Jewish background, which provided the basis for much of his imagery, and deliberately stood apart from the subject matter of French artists. Alone in his studio, Chagall's thoughts turned to Vitebsk (*The Cattle Dealer*; *To*

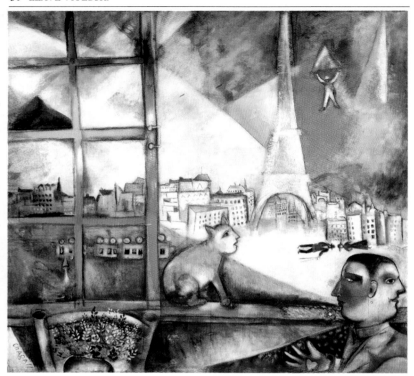

Russia, Donkeys and Others) and to the rituals of Jewish daily life (*Praying Jew*) from which he was isolated in Paris, where the diaspora was more inclined towards assimilation than religious practice. 'I have brought my subjects from Russia, and Paris has given them light.' Vinaver, his St Petersburg patron, came to Paris several times and was extremely satisfied with the work of his protégé, while a young journalist, the Russian free-thinker Anatoly Lunacharsky, submitted an article to a Kiev journal singing his praises.

'Perhaps my art is a wild art, a blazing mercury, a blue soul leaping up on my canvases'

In the world of dreams found in Chagall's pictures familiar characters appear: sheltering fiddlers and small

In *Paris Through My Window* (1913; above), Chagall is portrayed as Janus, looking towards both East and West.

carts, painted cows and lighted candlesticks, drunken soldiers on thatched roofs or gilded onion-shaped domes: so many familiar figures, a motley and whimsical bunch, brimming over in a mixture of dream and reality....

The humming of the samovar (the metal urn used in Russia for making tea), the cries of children, the hissing of a sledge, the smell of milking are just some of the simple and joyful activities that only Chagall is capable of evoking, in numerous tiny gouaches. Is it possible that the distant relationship with Henri 'Douanier' Rousseau inspired Apollinaire's elegiac verses in *Rotsoge*?

Moreover, it is clear that without knowing it, Chagall brought to the formalism of Cubism then dominant in Paris a new equilibrium through these representations of an imaginary world that bear the imprint of his native culture. No other poet or painter could have enriched

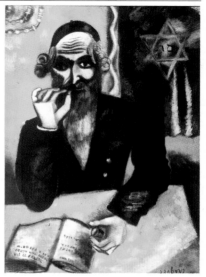

The Pinch of Snuff (1912), depicting a pious Jew, and *The Cattle Dealer* (1912; below), showing Uncle Neuch, evoke Chagall's childhood in Vitebsk.

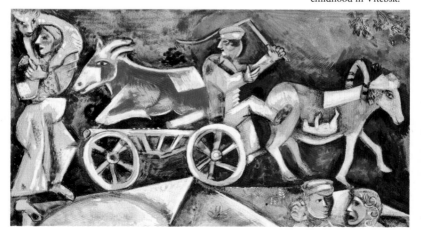

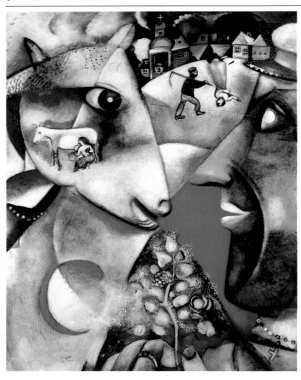

I and the Village (1911–4; left) is one of Chagall's most allusive paintings. His memory of his Russian village is symbolized by the animal to which he is bound by the almost invisible thread of his stare. The strange complicity between the man and the beast (both wear crosses around their necks) rests on the opposition of reds and greens. Turning to the couple in the background, the woman, symbol of fertility, appears to be fleeing from the peasant armed with a scythe (death). The tree of life and the sun eclipsing the moon at the bottom of the canvas add an irrational and 'super-natural' element to the painting and strengthen its scholarly symbolism. Below: catalogue of an exhibition of French painting held in Moscow in 1912.

the new Cubist pictorial language in such a dazzling way. His friends, including Delaunay, were struck by the subtle geometry underlying his compositions, but even more by the radiance of his colours, reinforced by a mixture of Russian folklore and anecdotal, irrational, psychic strangeness, 'a complete lyrical explosion' (André Breton), and, contrary to French harmony, founded on calm and on sensual pleasure.

'My paintings are arrangements of inner images that possess me'

The influence of Cubism on Chagall is revealed not so much technically in the fragmentation of surfaces

КАТАЛОГЪ
РАНЦУЗСКО
ВЫСТАВКИ КАРТИНЬ
ВРЕМЕННОЕ ИСКУССТВ

МОСКВА.
1912.

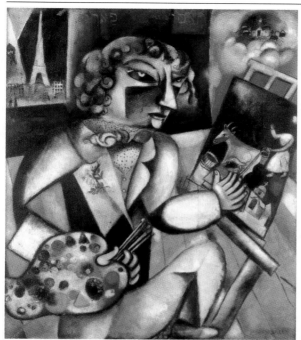

Self-Portrait with Seven Fingers (1913; left) could act as a counterpart to *I and the Village*. Chagall portrays himself as a successful painter, with elegant curly hair, dressed in the clothes of a Cubo-Futurist dandy, with an embroidered cravat and a flower in his buttonhole. On his easel, 'with seven fingers' – a Yiddish expression meaning 'at full speed' – he is completing what he then considered to be his best work: *To Russia, Donkeys and Others*. Turning his back on the lights of the French capital (represented by the Eiffel Tower), Chagall imagines himself once more in Vitebsk, evoked in a cloud at the top of the painting as though in a dream. In the guise of a halo above his head he writes in Hebrew lettering 'Paris' and 'Russia', thus affirming his affiliation to three cultures. Holding a palette with many colours, symbol of abundance and success, the artist has squared up his face in the Cubist manner. It is true that Chagall always remained on the fringes of any movement.

and volumes as in the positioning of formal elements in unusual juxtapositions on the same surface. His pictures are treated as psychic planes on which dreams and images are gathered in musical rhythms. They capture his recollection of the world and represent a sensual reality reinvented in a series of metaphors.

Thus *Self-portrait with Seven Fingers* depicts the elegantly attired artist at his easel, turning his back on the window and on the glittering lights of the Eiffel Tower, in the process of painting *To Russia, Donkeys and Others* – a fantastical view of Vitebsk – while to the right of his head the highly accurate memory of an orthodox church appears in an evocative cloud. The inscriptions in Hebrew lettering on the wall – 'Paris' on the left, 'Russia' on the right – are at once an echo of the modernist aesthetic of words in collage adopted by the Cubists and the (melancholy?) confession of an

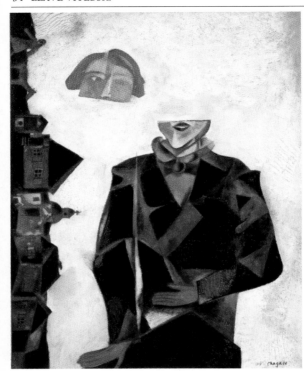

Anywhere out of this World (1915–9; left) clearly depicts the 'supernatural' world in which Chagall found his inspiration. Returning from Paris, where he had definitively 'found himself', he paints himself alone in this picture before his beloved town of Vitebsk. In a frosty, opaque and iridescent light, the village of faded wood, depicted in a naive and anti-naturalistic manner, stretches curiously along the side of the picture. The artist, who had forgotten the warm ancestral world to which he had belonged while in Paris, found himself there once again, torn between his attachment to his family and his adventurous destiny. The dislocated torso invades the canvas, dominating the village with an aura deprived of logic or gravity. Some, like André Breton for example, made a comparison between Chagall's work and De Chirico's, seeing that both shared the same illogical sentimental questioning and hallucinatory poetic symbolism. In any case, Chagall, who took the title of this painting from a poem by Baudelaire, instilled in this mysterious work, with its subtle geometric Cubist forms, an unequalled personal emotion.

uprooted youth, of an orphaned spiritual culture. Past and present are juxtaposed in a universal image which, adorned with the colours of his own unconscious, become pure poetic language.

Thus the distortions adopted by Chagall are not invested with the same meaning as those in the work of his contemporaries, such as Picasso. Where, in order to evoke, the Spaniard recomposes, the Russian juxtaposes and overlaps real facts re-experienced as though in a waking dream, an analytical introspection. This kind of bewitchment of the Chagallian ego appears again in *Maternity*. Amorous fantasies, imagination and nostalgia seem to liberate him to constant allegories of expiation, of which the painter, in the bottom right of the picture, is himself a part.

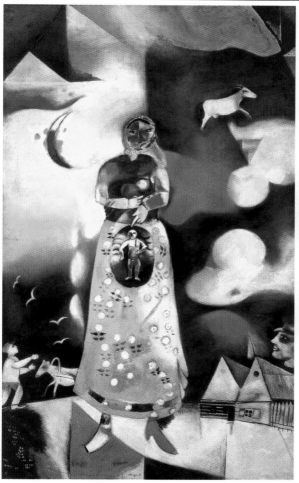

To find the measure of himself as a man was a constant preoccupation for Chagall, who, through his religious upbringing, had subjected himself to the rules of divine order. *Maternity* (1913; left), symbol of love and fertility, is framed in the clouds of the *shtetl* like a profane icon. The unborn child, the boy on the left and the painter on the right constitute the thread of an incantatory autobiographical narrative.

Inks and brushes

During this stay in Paris, Chagall perfected his method of working. On small sheets of paper, he would rapidly sketch ideas for compositions in pencil or ink, hardly hesitating or making any alterations. Several large line

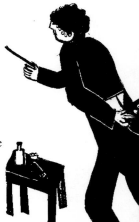

ШАГЛЛ НАДОЕЛ МНЕ ДУМАЮ ПИКАССО

chagall

Thinking of Picasso (1914; left) is perhaps the only work in which Chagall mentions and caricatures the illustrious artist, for whom he never had much liking. In *Self-Portrait with Palette* (below), he divides himself into several roles: he could be a magician in front of his table of tricks, a lecturer on his rostrum or an artist in front of his canvas. From his bag of tricks Chagall managed to create, quite consciously and with a touch of humour, magical works that widened the scope of French painting.

drawings, with just a hint of watercolour, formed a diary of daily life alongside his paintings in oils.

Owing to lack of money, he prepared small but elaborate gouaches on card as a basis for the large canvases. He liked to work the canvas in all directions, 'like shoemenders', thus emphasizing the importance of the centre, while reducing that of the height and width. With the painter's permission, *The Holy Carter* (1912) was hung upside down by Walden in Berlin.

Chagall also took handwritten notes, scribbled in little notebooks, mostly in Russian, occasionally in Yiddish, sometimes in French. He thus filled several notebooks with poems in a very Russian, extremely florid idiom, marked by the symbolism and popular expressions of his native land.

The period in Paris altered his character. The relative comfort provided by the monthly allowance sent to him by Max Vinaver, in addition to the genuine esteem in which he was held by his contemporaries gave him ambition and...made him show off. Like all his comrades, he had studied himself in the mirror since his formative years, but from 1910 the number

of self-portraits increased: a narcissism that was alien to his contemporaries. The reasons for this lay both in his search to find an identity in a foreign land (where he was unfamiliar with the language) and in the display of his many talents.

The perseverance of his friends, the poet Max Jacob, the critic André Salmon or the founder of the journal *Montjoie* R. Canudo played a part in the undeniable recognition that Chagall enjoyed during these years. Although the collector Jacques Doucet, under advice, was not interested in his work, Chagall signed his first contract on 30 April 1914 with the dealer Charles Malpel. Chagall returned to Russia enjoying a certain status and real glory.

Journey to Berlin

In spring 1914 Chagall travelled to Berlin for the opening of an exhibition at Der Sturm Gallery together with Paul Klee and Alfred Kubin, prior to having his first one-man show there. In 1910, the founder of Der Sturm, Herwarth Walden, had became the spokesman for Expressionism and, in 1912, for Futurism and was by then one of Berlin's leading exponents of art, known for publishing and showing the work of Die Brücke and Der Blaue Reiter, as well as the most innovative foreign artists: Umberto Boccioni, Wassily Kandinsky, Robert Delaunay, Alexej Jawlensky.... The new pictorial language of the art – about one hundred and fifty works on paper and forty paintings – that Chagall had brought from Paris could not fail to appeal to the public acquainted with the German Expressionist Franz Marc, for example: the exhibition was a triumph. Apollinaire's poem *Rotsoge* served as preface. During his stay, Chagall met some critics and visited museums, as well as a Van Gogh retrospective organized by the Paul Cassirer Gallery.

Unaware of the rumours of war, Chagall set off for Vitebsk on 15 June, the day after the opening, as he wanted to see his family again and Bella Rosenfeld, his

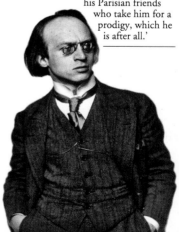

Founder of *Der Sturm* (The Storm), Herwarth Walden (below) said of Chagall: 'This young man with strange light eyes and curly hair is admired by his Parisian friends who take him for a prodigy, which he is after all.'

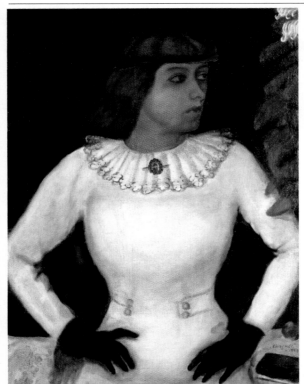

She comes in. Her voice rings out, she chatters to Thea.… I feel.…What do I feel?… That stranger's visit, and her singing voice, disturbs me, as if it were from another world. Who is she? I am afraid. No, I want to face her, to be near her.… Suddenly I feel that I should not be with Thea, but with her! Her silence is mine. Her eyes, mine. It's as if she had known me for a long time, and she knew all my childhood, my present, and my future; as though she had been watching over me, reading my inmost thoughts, although I have never seen her before. I knew that this was she – my wife. Her pale face, her eyes. How big, round and black they are! They are my eyes, my soul.

Marc Chagall, *My Life*

fiancée 'in black gloves' who had waited for him for four years. He left behind in Berlin and Paris all the works he had executed in over three years. Though he had only a three-month visa, he remained in Russia until 1922.…

Rediscovering Vitebsk, rediscovering Bella

'I knew that this was she – my wife.' Bella Rosenfeld came from a family of upper-middle-class merchants and had studied in Moscow. From the moment they first met in 1909, Chagall (whose background was more modest than hers) idealized this strikingly beautiful woman, while she was totally captivated

Above: Bella Rosenfeld.

by his mercurial personality. Bella's cultured and perceptive nature, her knowledge of classical European painting, of the theatre and poetry (she introduced Marc to the work of Baudelaire) were the focus of a passion that lasted over thirty years.

Their meeting is related in two moving and complementary accounts, one written by Marc Chagall himself in *My Life*, the other by Bella Chagall in *Lumières allumées – Première rencontre* (*Burning Lights – First Encounter*), dedicated to her husband in 1939. These two books are a lyrical evocation of the love that bound these two beings, so different, yet so passionate.

The marriage lasted until Bella's tragic death when they were in exile in the United States in 1944. They had been married in a religious ceremony on 25 July 1915 and a year later Bella gave birth to a daughter, Ida. In later years Ida played a decisive role in the international recognition of her father's work, displaying her total devotion, fighting spirit and refined taste. Together these two women, Bella and Ida, swore to love, protect and defend him.

During the war years, which he spent in both Vitebsk and St Petersburg (renamed Petrograd in 1914), Chagall was faced with four simultaneous revolutions: revolution in the plastic arts, revolution in the theatre, political and social revolution, and revolution in Jewish modernity.

My *Fiancée in Black Gloves* (1909; opposite) seems a distant and inaccessible model to the young Chagall who fell in love with her, while the drawing *Bella and Ida* (1916; above) represents a tender and caring mother. The couple was inseparable and their daughter was the apple of their eye (left). Chagall executed few portraits of Bella, whom he preferred to idealize in the numerous pairs of lovers in his canvases. Apart from a few images of his nearest and dearest, he showed little interest in portraiture, though he did paint a number of self-portraits until his death, revealing his continual search for identity.

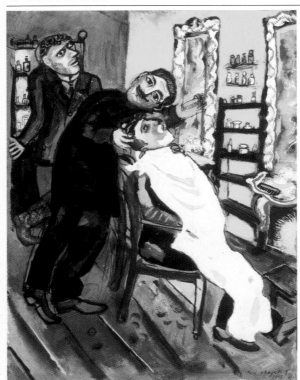

S tranded in Vitebsk when war was declared, Chagall painted several vignettes of family life, such as *At the Barber* (1912; left), adopting a restricted but strong palette, and with his characteristic blend of fantasy and directness. While he had been acquainted with the work of the Douanier Rousseau in Paris, notably through Delaunay, he also drew inspiration from popular art forms such as signs or *loubki*. These traditional prints had always formed part of Slav folklore: contrasting colours, arranged in blocks, accentuated outlines, exaggerated expressionism both in form and composition were some of the elements characteristic of the Russian soul.

A bove: Chagall in Moscow in 1914.

What is more, he was witness and protagonist in each of them, before being forced into exile for good.

How would this young father have described himself? Russian? French? Jewish? European? An atheist? An artist? A politician? These were the inner voices to which he had to listen, respond and find a way of living, until he renounced his nationality in 1922.

After the First World War and his return to Paris, he illustrated *Dead Souls* by the Russian writer Gogol as well as the *Fables* of the French poet La Fontaine, before turning to the Bible, with its universal message. This multiplicity of interests and his refusal to abandon

any of them is perhaps what continues to place Chagall above nationalism and aesthetic trends today, right at the heart of humanity.

Russia at war

August 1914: when Germany and Austria-Hungary declared war on Russia, Chagall was trapped in his own country. Thanks to his brother-in-law, the brilliant economist Iacov Rosenfeld, he was granted exemption from military duties and made press officer of the Ministry of War Economy in Petrograd. Here he filled

War and famine inspired the painter to produce some bitter ink drawings in 1914: *The Departure* (above) and *The Soldiers* (overleaf). His virtuosity with the pen is apparent in his illustrations for *My Life*.

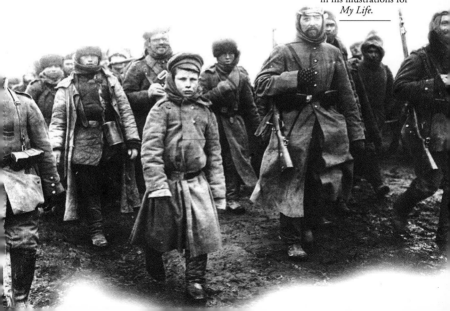

with scribbled notes the first of nine exercise books that were to constitute, in 1923, the manuscript of *My Life*.

The recognition Chagall enjoyed led him into literary circles: the Russian poets Vladimir Mayakovsky, Sergey Esenin, Aleksandr Blok and the young Boris Pasternak urged him to publish his views through articles in the press.

Returning to Vitebsk, a small, gloomy town, isolated and well away from the front, Chagall renewed his ties with his family. His pictures of this period are of domestic scenes: *The Bakehouse, The Kitchen, Interior with Strawberries, Lilies of the Valley, View from the Window*, and portraits of the close relatives with whom he was reunited. French modernism was forgotten in these 'documents' (to adopt his own expression) full of sentiment and tenderness. Chagall again confronted reality directly, transcending the humble subject matter in order to capture a mysterious and infinite tenderness.

However, the influx of wounded, the poverty, the cold and the dividing of families made Vitebsk a sombre place. *Soldiers, The Wounded Soldier, Infirmary, Loaves of Bread* form a poignant chronicle of human suffering. A series of vignettes in Indian ink is like a cry of agony, denouncing the horrors of war and portraying humankind's despair.

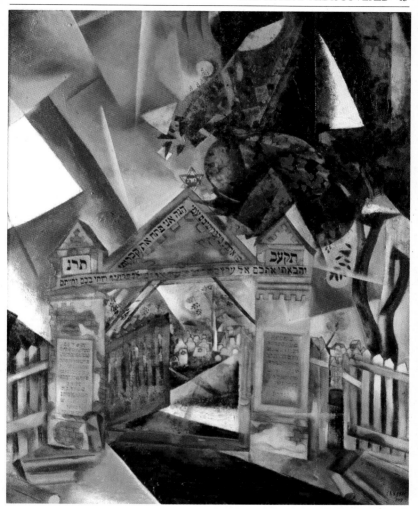

'There is no spirit more free and unexpected in his creative ideas than this God-intoxicated Chagall' (Efros)

Since the early days of the conflict, the Jews were suspected of spying and in May 1915 all those living

The Cemetery Gates (1917; above) is one of the carefully executed works inspired by his return to the Jewish quarter.

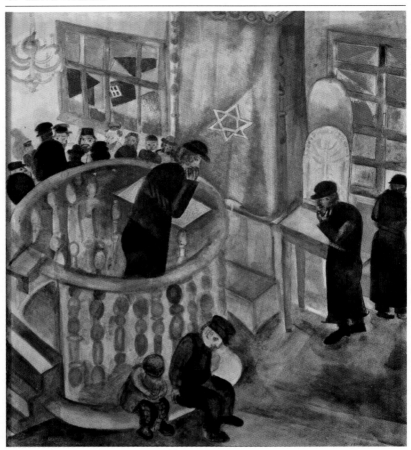

near the borders – more than 200,000 Jews – were ordered to leave Lithuania within twenty-four hours. Vitebsk took in thousands of refugees. In these terrible circumstances, without becoming religious, Chagall rediscovered his Hassidic roots. Between 1914 and 1917, an impressive body of quiet paintings bears witness to his respect and compassion for these old Jews, wandering preachers to whom his family willingly offered hospitality during this period of war and famine. These pictures reveal his devotion to the Law

In painting *The Synagogue* (1917; above) Chagall captured, as he did in *My Life*, the relaxed atmosphere that reigned in the synagogue, to which only men were admitted: while one reads the Torah, others study, chat or doze.

and his knowledge of the Talmudic scriptures: *Rabbi with a Lemon* (or *Feast Day*), *Praying Jew*, *Red Jew*, *The Cemetery Gates*, *The Synagogue*.... Some of them (*Purim*, *Succoth*, *The Baby Carriage*) are sketches for a mural decoration he was to have painted for the great synagogue in Petrograd in 1917, but the first riots in February naturally prevented it from being carried out.

Chagall painted several old wandering Jews, including *Red Jew* (1915; above). 'A shadow, coming straight from my heart, fell on him.' (*My Life*)

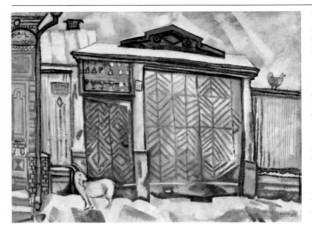

In 1917 Chagall painted a highly accomplished series of landscapes, including *The Red Gate* (left) and *The Blue House* (below). In *The Blue House* the colour contrasts of the purplish blue rustic wooden house, the red roofs of the monastery, the white walls of the church and the dark waters of the Dvina river in which the town is reflected create a powerful effect. The minute detail with which Chagall paints the flowers at the bottom of the canvas is found again in *Bella with a White Collar* (opposite left) and *The Birthday* (opposite right) and *Over the Town* (overleaf).

He executed some small ink drawings to illustrate three texts in Yiddish, a novel by Peretz (*The Magician*) and two stories in verse by Der Nister (*With a Little Rooster* and *With a Little Goat*), adopting a sharp linear style similar to the Hebrew alphabet. At the same time, he painted a series of highly accomplished views of his native town, which were begun outside in the open air and completed in the studio. In *The Red Gate, The Grey House* and *The Blue House* the natural scene – attractive

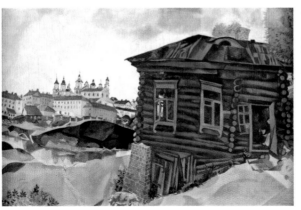

• "Today is your birthday!... Don't move, stay where you are...." I still have the bouquet in my hands.... You have thrown yourself into a canvas which trembles in your hands. You plunge your brushes into the paint. Red, blue, white, black, the colours splash out. You surround me with a torrent of colours. Suddenly you lift me from the ground; you make a leap as if the...

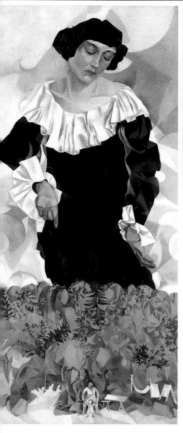

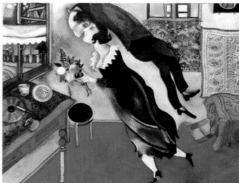

Russian wooden houses painted in radiant colours – has been transformed using the Cubist medium into a poetic and dreamlike vision of reality. Between 1916 and 1917 Chagall exhibited his work several times. Not yet thirty, he was recognized as one of the major artists of his generation. Homage was paid to him in Petrograd as well as in Moscow, at the gallery of Nadezhda Dobychina, at the 'Knave of Diamonds' exhibition and many of his works were acquired by some of the great collectors, such as Morozov, Wissotzki and Kagan-Shabshay, who wished to open a Jewish museum.

Despite the gloomy events of the outside world, the war years were a happy time for Chagall, because of his great love for Bella. The tender and joyful masterpieces of this period – the series of four small paintings of 'Lovers' (gathered under the title *Dedicated to my Wife*) the large-scale, highly unusual and radiant canvases,

…room were too small. You stretch up to the ceiling. You turn your face towards me, you make me turn mine… in unison, we both rise up above the room and begin to fly. We want to leave through the window. Outside the sky is calling us.●
Bella Chagall
Première Rencontre,
1973

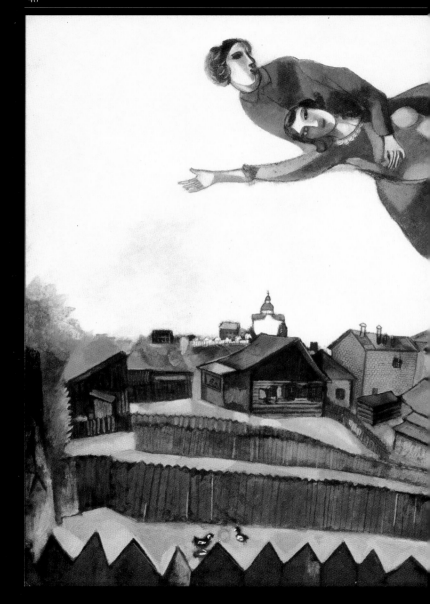

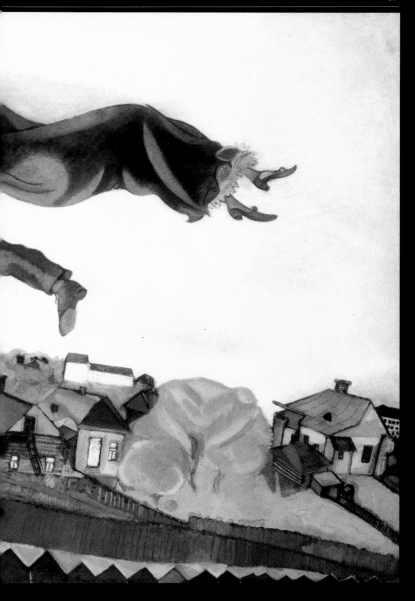

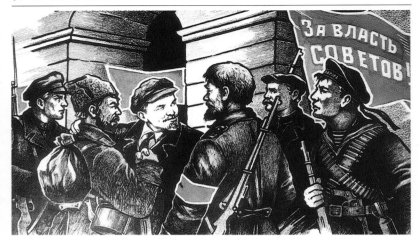

Bella with a White Collar, Over the Town, Double Portrait with a Glass of Wine, The Birthday, all inspired by Bella, gave expression to his feelings.

Commissar of Fine Arts

Despite the chaos, the outbreak of the October Revolution of 1917 marked a tremendous liberation for Jews in all the Russias: they finally obtained equal civil rights before a new wave of anti-Semitism appeared.

After the publication of his first monograph (by Abram Efros and Yakov Tugendhold) and the 'First Official Exhibition of Revolutionary Art' in the Arts Museum in Petrograd – where an entire room was dedicated to his work – Chagall had an unexpected success in politics: 'The actors and painters had gathered in a meeting at the Michailovsky Theatre [in August 1918]. They mean to found a Ministry of Arts. I attend as an onlooker. Suddenly, I hear my own name proposed for minister by the young artists.' Meyerhold was to be responsible for theatre, Mayakovsky for

In 1918 the first monograph (below, the cover) devoted to Chagall was published by Abram Efros and Yakov Tugendhold in Moscow.

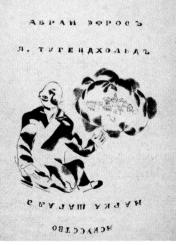

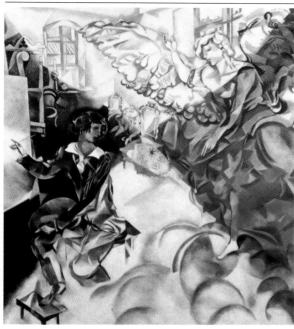

'1919 was a terrible year. The era of battling Communism was at the height of its crisis. But Russian culture blossomed and gave rise to a veritable flood of projects and initiatives.'
Abram Efros

In *The Apparition* (1917–8; left), Chagall, who had become acquainted with the Cubo-Futurist art of the Russian painters already tried by Mikhail Larionov and Natalya Goncharova, began to challenge the traditional treatment of form. The encounter between the angel and the painter confers on the work a lofty grandeur, in the form of a contemporary icon. Chagall took part in several exhibitions, while an entire room was devoted to his work in the Winter Palace (below, the catalogue).

literature and Chagall for fine arts. On Bella's advice, he refused the invitation.

He preferred to go to Moscow, the new Bolshevik capital, where he again came across Anatoly Lunacharsky, who had not forgotten their meeting in Paris and was to be of invaluable support to Chagall on several occasions. Elected Commissar for People's Education and Culture, Lunacharsky was close to Lenin and, in 1918, was director of Narkompross (Ministry of Culture and the Arts) in the Kremlin. On 12 September 1918 Chagall was nominated Commissar of Fine Arts 'responsible for artistic affairs in the province of Vitebsk', and charged with 'organizing the art schools, museums, conferences and all other arts activities in the town and region of Vitebsk'. The experience, born out of the most

In 1945 Chagall commented: 'The Revolution troubled me because of the incredible dynamic vigour that penetrated you completely, exceeded your imagination, unfolded in your own inner world. And all this at the same time in which your inner, artistic, world also seemed to you like a revolution. The backlash of these two revolutions is not always a happy one.' To mark the anniversary of the Revolution, he painted designs for banners, such as *Rider Blowing a Trumpet* (1918; below). *Cubist Landscape* (1918–9; opposite) is Chagall's only strictly Cubist work.

passionate enthusiasm, was to be short-lived, and ended in bitterness and disillusionment.

'Vitebsk has begun to move. The art of the Revolution has reached this "hole" of a province'

The planned academy of art and museum were inaugurated in Vitebsk on 28 January 1919 in the former residence of the banker Vishnyak that had been requisitioned by the revolutionary army. The first exhibition Chagall organized there was devoted to the work of local artists.

To mark the first anniversary of the Revolution, on 6 November 1918, Chagall spared no expense, and showed an extraordinary talent for organization. The whole town was decked with flags and all its artists, including Alexandra Exter, David Sterenberg and Natan Altman, were mobilized. Seven triumphal arches spanned the main streets, while the squares were decorated with three hundred and fifty streamers, the shop windows with garlands and the trams with flags

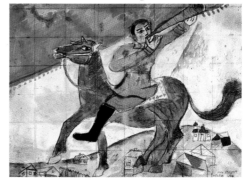

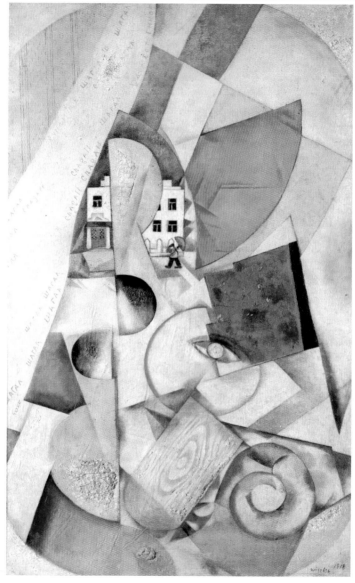

– 'street art' in the most literal sense of the term. Chagall himself donated some gouaches intended to be enlarged as banderoles: *Onward, War on Palaces....* He published in *Revolution in Art* an article that made a great stir.

From the Free Academy to the Suprematist Academy

Chagall showed great enthusiasm and imagination in his work with the school and exemplary devotion to the proletarian revolutionary cause. The 'Free Academy', the only truly creative artistic environment in Vitebsk, soon numbered no fewer than six hundred pupils who were taught by Yehuda Pen, as well as painters from the capital, Mstislav Dobuzhinsky, Ivan Puni (Jean Pougny) and A. Rom, in communal studios where numerous lectures and debates took place. El Lissitsky ran the graphic art department, while Chagall was in charge of the painting department with Vera Yermolaeva, who had been sent by the authorities from Petrograd. Yermolaeva and Lissitsky quickly imposed as a professor the charismatic but poisonous Kasimir Malevich, who was openly hostile to Chagall. The leader of the Suprematists, who had just exhibited his *White on White* series (1917–8), was in favour of radical Constructivism and revolutionary dogmatism. For Chagall, already undermined by attacks from philistines and members of the Bolshevik party, the rivalry was too much.

A few months later, returning from a trip to

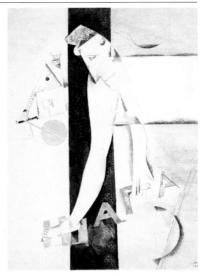

After completing this self-portrait (1918; above), a *trompe l'oeil* collage, Chagall met Granovsky, Mikhoels and Meyerhold (below), champions of the Yiddish theatre in Moscow.

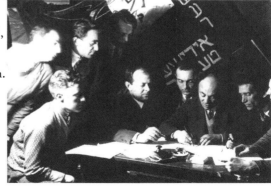

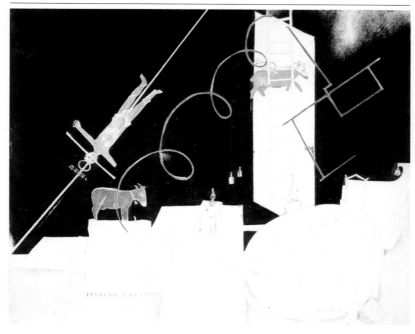

Moscow to procure 'bread, paints and money' for the school, Chagall was dismissed and actually expelled by his so-called friends. In his absence, they had converted the school into a 'Suprematist Academy'.

Last stop: Moscow

In May 1920 Chagall and his family decided to leave Vitebsk for good and head for the capital, where the avant-garde of the Russian theatre was in turmoil. Bella, who had a passion for the theatre, certainly had a say in this decision.

In the indescribable tumult of the civil war, which erupted in 1920, and the hardships of the famine, Chagall gained a formidable reputation. Though he was regarded with suspicion for rejecting the revolutionary diktats on art, he nevertheless enjoyed international fame. Chagall produced several theatre

In 1921 the Moscow Art Theatre commissioned Chagall to design the set of Synge's *Playboy of the Western World* (top). However, the design was rejected, as it went against the naturalism in vogue.

designs: the set of Gogol's *The Inspector General* for the Theatre of Revolutionary Satire and the set of Synge's *Playboy of the Western World* for the Moscow Art Theatre.

Despite Chagall's opposition to Suprematism, this brief period, which witnessed the flowering, in the work of Vladimir Tatlin, for example, of a 'Revolution style', is characterized by his questioning of figurative composition and by a new approach to theatrical space. Chagall broke new ground, experimenting with abstract geometric forms and different planes that corresponded to the norms of watchful Bolshevik critics.

After his initial work in the theatre, he was commissioned in November 1920 by Aleksey Granovsky, the young director of GOSEKT, the State Jewish

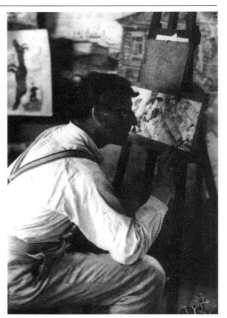

Chamber Theatre in Moscow – at Efros' suggestion – to create new stage sets. Three short plays were performed for the first time on 1 January 1921 – *The Agents*, *Mazeltov* and *The Lie*, grouped under the title *Miniatures* – in an evening dedicated to the celebrated Yiddish author and playwright Sholom Aleykhem, who had died in 1916. Forbidding anyone to enter, Chagall worked day and night for two months and 'decorated' the entire space at his disposal. A patrician apartment seized by the government was converted into an auditorium that could accommodate eighty spectators.

'Chagall's box', as it was nicknamed by his friends and enemies, consisted of nine monumental murals, seven of which survive today: a central panel, *Introduction to the Jewish Theatre* (3m × 8m; about 13 × 39 feet); a narrow frieze; *Table Laid for a Celebration* (8m long; 39 feet); four panels, *Literature, Theatre, Music, Dance*; lastly, *Love on the Stage*. In these Chagall painted a visual manifesto of the theatre in the Yiddish language: 'Here's

•Jewish theatre has need of the most Jewish, the most modern, the most unusual, the most complex of all artists,• Efros declared. For the set designs of the *Miniatures*, commissioned by the new Jewish Theatre in Moscow, Chagall painted nine panels in two months. The study for *Introduction to the Jewish Theatre* (above) reflects the painter's boundless energy. 'Very soon our little stage became too small for him.... The whole theatre was *Chagallized*,' Efros recalled.

an opportunity to shake up the old Jewish theatre, its psychological naturalism, its false beards. There, on the walls at least, I can let myself go and freely show everything I think necessary to the rebirth of the national theatre.'

This ensemble had an explosive effect as it underlined the pre-eminence of an ethnic cultural identity over the centralized Russian hegemony. Chagall felt increasingly ostracized; his set designs were not understood and he was never paid; every day his painting came under more violent attack from Rodchenko, Kandinsky and Malevich and Lenin denounced the 'spiritual confusion of the Leftist trends'. By the winter of 1921–2, Chagall was reduced by the Narkompross to teaching drawing in two colonies for war orphans, Malakhovka and the Third International, both on the outskirts of Moscow. The situation was untenable.

'I did not leave Russia for political reasons but for artistic ones'

Incomprehension, rivalry and rejection, the volatile political situation and the famine led Chagall, who was anxious and bitter, to foresee his disgrace and opt for exile. The opportunity to leave Russia arose the following summer: a poet named Jurgis Baltrusaïtis, the Lithuanian ambassador, organized an exhibition of his work in Kaunas. Chagall set off immediately, with a visa granted by Lunacharsky and permission to export about twenty canvases.

A few days after the opening of the show, he set sail from Riga for Berlin, where he was joined by his wife and daughter shortly afterwards. A new life awaited him.

Chagall was extremely bitter about the reactions to his designs for the Jewish Theatre. Humiliated and given a minor post as a drawing teacher (below), he decided to go into exile.

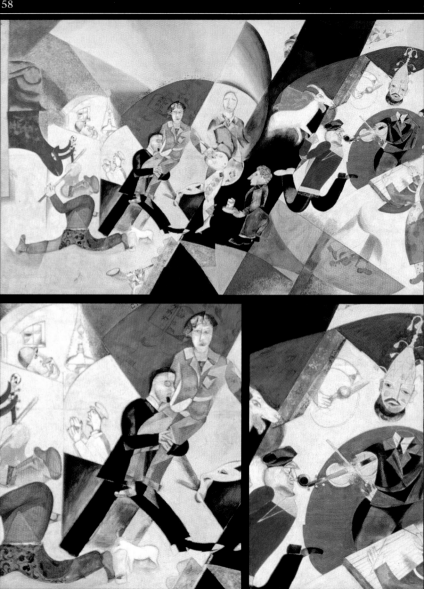

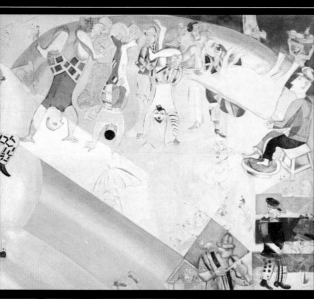

The designs for the Jewish Theatre

In the *Introduction to the Jewish Theatre* (left), an immense Jewish *commedia dell'arte*, Chagall showed no hesitation in depicting himself (left, held in Efros' arms) as Moses, beside the tablets of the Law. The mural caused a great stir in combining 'Suprematist' geometric composition with Jewish iconography in a parodic and grotesque carnival. The details at the bottom show: Efros carrying Chagall (left); a 'decapitated' violinist wearing a jester's hat, and a clarinettist (centre); two clowns walking on their hands, one of whom is a religious Jew wearing tefillim, turning the old Jewish world upside down (right). Removed in 1923, these designs were hidden in 1937, at the height of Stalinist anti-Semitism, under the theatre stage then at the Tretyakov Gallery in Moscow, before being unrolled in 1973 for Chagall, who signed them on this occasion. Shown to the public for the first time in 1991, at the Gianadda Foundation in Switzerland (which had paid for their restoration), they are now back in the Tretyakov Gallery.

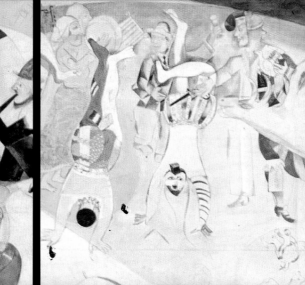

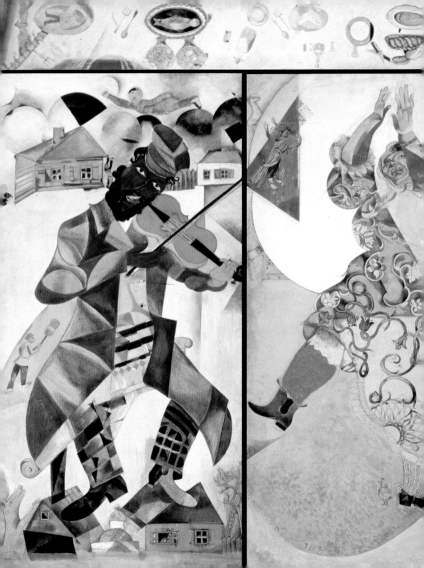

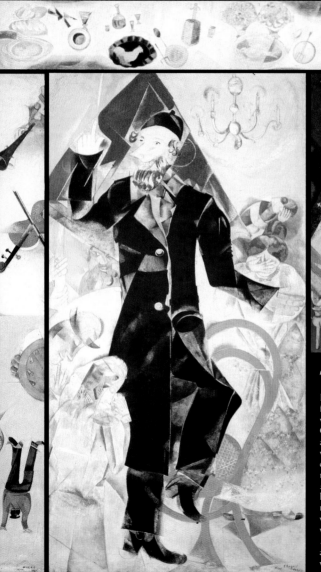

Top: *Table Laid for a Celebration.*
From left to right: 'the four arts' of the *shtetl*, which, according to Chagall, were: *Music* – a *klezmer*, the violinist who precedes the bridal couple; *Dance* – a matchmaker, the *shadkhan*; *Theatre* – here represented by the *badkhan*, the jester who accompanies the wedding procession; *Literature* (above) – a *soyfer*, the scribe who copies the Torah.

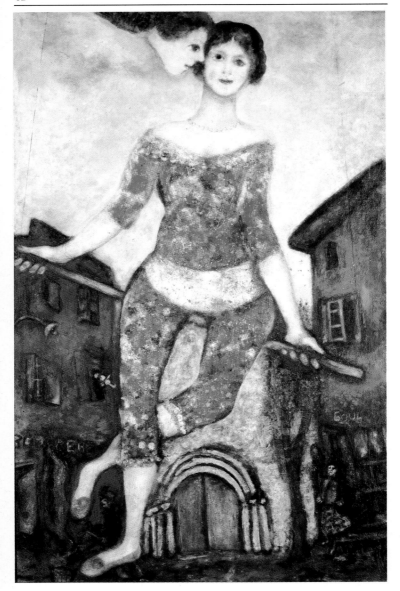

The road into exile led Chagall to Berlin, then to Paris. Success meant the painter and his family could live comfortably. They travelled throughout France, exploring the provinces. Chagall was granted French nationality by the Popular Front, but the Nazi threat was already looming. In 1941 the Chagalls fled Vichy France for Portugal, and from there set sail for America.

CHAPTER 2
RETURN TO PARIS

The period between the wars was a tranquil one for Bella, Ida and Marc Chagall (right), who had settled in France, and he spent his time developing his themes and technique. In *The Acrobat* (1930; opposite) and other works he captures the glittering world of the circus. Using a more subtle and 'rounded' brushstroke, Chagall depicts an equestrienne and her lover in front of one of the churches discovered on a trip to the Auvergne.

Berlin, 'a veritable caravanserai, a meeting place for emigrés'

After leaving Moscow in July 1922, Chagall and his family settled in Berlin, where they remained until August of the following year. In the early 1920s Berlin was an exotic caravanserai of wanderers and emigrés fleeing from Russia and central Europe. Ruined aristocrats rubbed shoulders with adventurers of all sorts, with prostitutes or pimps: they were all satirized by the Expressionists Georg Grosz, Otto Dix and Max Beckmann in their sketches and drawings with savage accuracy.

Chagall humorously recalls: 'In the apartments in the Bayerischesplatz, there were as many samovars and theosophic or Tolstoyian countesses as there had formerly been in Moscow.... As for myself, I had never seen so many extraordinary rabbis nor so many Constructivists.'

It was a testing period for the artist, who witnessed the consequences of the Spartacist riots and the staggering devaluation of the mark. He wished to contact Herwarth Walden again and lay hands on the money that the latter owed him after his exhibitions at Der Sturm Gallery in spring 1914, but his acrimonious dispute with the dealer led nowhere: the amount owed to him, deposited for eight years with a solicitor, was now worth nothing. 'Seven and a half billion marks were being exchanged for a dollar, an authentic Dürer for two bottles of whisky,' Klaus Mann recalled. Chagall was ruined.

Following lengthy legal proceedings, Chagall was eventually able to recover just three of the paintings

In 1914 Chagall had spent only a few days in Berlin (above), but he stayed for over a year, from 1922 to 1923, while the dispute with Herwarth Walden and his Swedish wife Nell dragged on. While Georg Grosz and Raoul Hausmann denounced the bourgeoisie at the International Dada Fair in 1920, El Lissitzky, Naum Gabo or Ivan Puni, who had recently arrived from Russia, exhibited at Walden's or the Flechtheim Gallery. Chagall's art received recognition in the press: from Theodor Däubler in *Der Cicerone*, from Efros and Tugendhold in *Das Kunstblatt*.... In 1937, however, the Nazi exhibition of 'Degenerate Art' (left, the catalogue) was merciless on the avant-garde: Dix, Ernst, Grosz, Kandinsky, Kokoschka, Nolde, and...Chagall.

that remained in the gallery, as well as ten gouaches, from Nell Walden, the dealer's first wife.

Apprenticeship in engraving: *Mein Leben*

In spring 1923, Paul Cassirer and the director of his gallery, Walter Feilchenfeldt, suggested that Chagall publish *My Life* in German, illustrated with etchings. Because of the difficulties in translating the Yiddish manuscript, the book was not in fact published until 1931 in Paris, where it was transcribed by Bella with the assistance of a young writer, Jean Paulhan. However, Cassirer produced a folio edition of engravings for *Mein Leben*. At the age of thirty-five, Chagall discovered engraving techniques, exploring for the first time the possibilities of the burin and of drypoint. He became passionately interested in this new graphic medium – 'I was ready for it' – and within a few years became one of the uncontested masters of it. Under the guidance of the engraver Hermann Struck, he executed in a few weeks twenty copper plates, from which he concluded: 'The line that is drawn and the line that is engraved are essentially different.' In the same vein, he tried his hand at lithographs and woodcuts in the studio of Budko. He was determined to perfect the seventy prints he had undertaken and therefore painted very little during his thirteen-month stay in Berlin.

Between two visits to the Black Forest and Thuringia – from which several landscapes on paper remain – the Chagalls received a letter from the 'Good Comrade'

Encouraged by Paul Cassirer (below) in Berlin, Chagall discovered the possibilities of engraving. The twenty illustrations planned for *Mein Leben* (*My Life*) adopted the original text on his youth in Russia and took up the drawings from Vitebsk (above and left).

of earlier times, Blaise Cendrars, of whom they had received no news for seven years: 'Come back, you are famous. Vollard is waiting for you.' On 1 September 1923 the Chagall family arrived in Paris.

'My art needed Paris, like a tree needs water'

Chagall first found his studio at La Ruche, abandoned since 1914, completely ransacked. After his enforced departure from Russia and the quarrel with Walden, he felt very bitter. Although he was recognized throughout Europe, he no longer possessed any of the works from his youth that had earned him his fame. He viewed the thefts of Berlin and Paris as a mutilation.

Between 1923 and 1927 Chagall concentrated on repainting from memory, or from reproduction, new versions or replicas of his earlier works – such as *The Birthday*, *Jew in Black and White*, *Over Vitebsk*, *I and the Village* – patiently reconstructing his sensory and emotional heritage. It is not the right place to examine the complex psychological experience of this return to the past here, but it is true to say that these copies reinforced his structural and formal memory, allowing him to gather strength and energy again. These stylistic exercises showed his unshakeable attachment to these important early works.

Meeting Vollard: *Dead Souls*

For a long time, the dealer Ambroise Vollard, whom Chagall had met in 1923, had been passionate about books. Once the war was over, he began publishing in Paris new books illustrated by the greatest artists of the time. At Cendrars' suggestion, he proposed that Chagall illustrate *General Dourakine* by the Comtesse de Ségur, but the painter rejected that 'romantic novel', preferring one of the masterpieces of Russian literature, Nikolai Gogol's *Dead Souls*. Between 1923 and 1925 Chagall worked with Picasso's printer, Louis Fort, creating 107 masterful plates to illustrate this powerful picaresque tale. Vollard could not disguise his satisfaction: 'Chagall has succeeded in rendering, with what truth,

Ambroise Vollard (below and opposite, in the company of the Chagall family), Picasso's first dealer, was without doubt the greatest publisher of prints in the 20th century. On seeing at the home of the critic and collector Gustave Coquiot small works by Chagall, the enterprising dealer was so impressed that he offered Chagall, who had just returned to Paris, a contract that lasted until the Second World War. *Dead Souls*, the *Cirque Vollard* series and *The Bible* are the dazzling results of this successful collaboration between the painter and dealer.

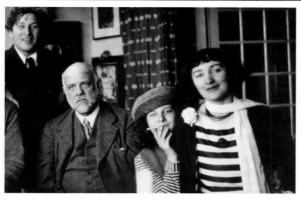

The plates of *Dead Souls* were not published until 1948 – by the publisher Tériade – nine years after Vollard's death. The treatment in drypoint and aquatint (below, detail from *Dead Souls*), as well as the superb quality of the printing, make it a major work. In a style that recalls the French graphic artist Honoré Daumier in its sharpness and caricature, Chagall portrays the corrupt humanity described by Gogol with savage accuracy.

the slightly Louis-Philippian look that characterizes the Russia of Gogol's time.' The painter really identified with the writer. The vividness and brilliance of Chagall's graphic work complemented Gogol's baroque and witty writing. With a 'modern' eye, Chagall conjured up the folklore of his native land and bestowed on the characters of the novel a lively and whimsical immediacy, full of humour and Russian flavour: Chichikov, the swindler or Sobakevich, the glutton.... The wealth of texture, the proliferation of unexpected angles heighten the readers' curiosity, inviting them to refer to the text on the facing page. Chagall made a name for himself as a master of black-and-white engraving, a so-called minor genre which he raised to a noble status. The inspiration that sweeps through the tale involves more than the magic of the printing. Chagall has added a poetic dimension, giving expression to a pictorial metaphor that did not escape André Breton, the leader and principal theorist of Surrealism: 'Through Chagall alone, metaphor makes its triumphal entry into modern painting.'

His first success in Paris

The move to the former studio of Eugène Zak in the Avenue d'Orléans early in 1924 marked the beginning of Chagall's success. Hangings from Bukhara and cashmeres, comfortable sofas: the photographs of this period show a happy and relaxed man, totally devoted to his family and his art. Free at last from material concerns, he is pictured in a room decorated in a cosmopolitan and, to western eyes, almost oriental way.

He did not live in the same opulence as Matisse and Picasso, but he was undeniably comfortable nevertheless, a fact that filled Chagall with legitimate pride. The vogue for things 'Russian' in Paris at the time was as much due to Marc Chagall as to Serge Diaghilev and Igor Stravinsky.

During this period Chagall experienced a new sensation: complete satisfaction. From 1925 his paintings glow with happiness in the face of requited love. Ultramarines and golds, cobalts and vermillions

This portrait of Ida (above left), the only one known, was painted in 1924 at the Ile de Bréhat, where Chagall also executed several landscapes. Some critics have pointed out the similarities – in terms of composition and the fluid brushstrokes – between some works by Chagall during the 1920s and paintings by Henri Matisse or André Derain, although Chagall was not profoundly influenced by them. An inner peace emanates from the canvas, which looks like a hymn to paternal love. Above: the Chagalls.

all unite in a dazzling symphony of colour. The artist indulges in the peaceful inner melody of his own world. Couples, flowers and pastoral landscapes all testify to a long-awaited serenity.

In *Double Portrait* (1925; above), Bella, radiant and beautiful, is his muse.

An independent thinker

Though the Montparnasse of the 'roaring twenties' was alien to him, Marc Chagall enjoyed re-exploring Paris with Bella at his side. He took up with the friends from his youth: the Delaunays, André Salmon, Louis Marcoussis, and made new friends: the art critics Florent Fels and Gustave Coquiot; the poet Ivan Goll and his wife Claire; the writer Marcel Arland; the poet and art critic René Schwob;

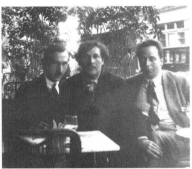

Raïssa and Jacques Maritain the philosopher; Christian and Yvonne Zervos, publishers of *Cahiers d'art.*

Above: Chagall (centre) seated with Joseph Delteil (left) and Robert Delaunay (right).

The entire intelligentsia recognized Chagall as a true master and one of the most creative. Exhibitions of his work were held with increasing frequency, both in Paris, at the Katia Granoff, Bernheim-Jeune and Portique galleries, and abroad, in Europe and America.

Chagall and his family did not lead a busy social life, partly because of language difficulties, but mainly because of Chagall's deeply independent nature. For him, Paris meant above all the rediscovery of freedom. Having participated enthusiastically in the Russian Revolution, he was confronted with the harsh partisan struggles and had shed many of his illusions. From now

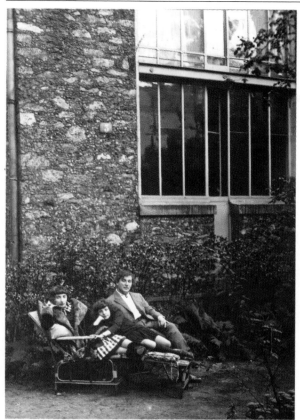

Œuvres
de
MARC CHAGALL
de 1908 à 1924

GALERIE BARBAZANGES
HODEBERT Successeur
fg. Saint-Honoré
109
Paris

The Paris of the 'roaring twenties' included the popular Terrasse de la Rotonde (opposite top) in Montparnasse. In his new studio in Boulogne (left), Chagall prepared for his first retrospective exhibition in Paris at the Barbazanges-Hodebert Gallery (above) in 1924. Delaunay had also exhibited there with Marie Laurencin in 1913. In 1928 André Salmon (opposite below), who initially wanted to translate *My Life*, published the first monograph on Chagall in French before Waldemar George.

on he took a solitary path. When the young Surrealists Max Ernst, Paul Eluard and his Russian wife Gala asked him in a friendly way to join them – quite logically, to judge by his works from the period 1911 to 1913 – he refused. Their venture seemed too literary to him and he was suspicious of the automatism on which many of their theories rested. 'Intentionally fantastic art is alien to me.'

Rather than adhering to new manifestos, Chagall preferred to explore a quality peculiar to traditional landscape: light.

In 1925 Chagall painted this *Landscape at l'Isle-Adam*, a work unusual for its airy naturalism, near Pontoise where the Delaunays had a house. At the same time, Robert completed a portrait of Bella in which she is characterized by her adolescent charm and wearing one of the celebrated rainbow dresses designed by Sonia. That same year, Philippe Soupault wrote in *Feuilles libres*: 'Physically, Marc Chagall is a strong man, with wide shoulders and a strange head with a rugged face. Two eyes, like everyone else, two eyes like no one else: shining with anger and mildness, piercing and darting, misty and shiny; the eyes of a bird of prey or a mystic. A gaze that penetrates you like a chill wind. He speaks and his enthusiasm bowls you over, dominates you, makes you understand, frightens you. You see in a word, in a gesture, a strength, and suddenly you feel ready to help him because of his frailty, warm, likeable, almost sensitive. Sensitive, I repeat this word, sensitive and I would like to write: Chagall is a sensitive insensitive.'

'The land of France...a beloved subject' (L. Venturi)

Whereas on his first stay he had never been able to leave Paris because of lack of money, this time Chagall – and his wife – travelled extensively throughout France between 1923 and 1938, visiting some of the great European museums. Between 1924 and 1925 they stayed with the Delaunays at l'Isle-Adam, then in Normandy and in Brittany on the Ile de Bréhat. Chagall's painting at this time reflects the artist's sense of wonder and amazement at the French countryside and his feeling of peace, a moment of reflection in the turmoil of his inner world.

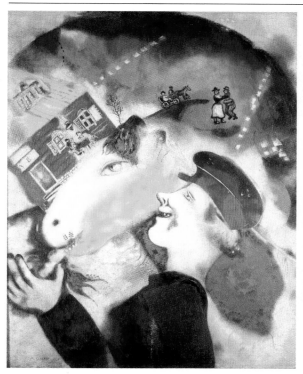

His oeuvre was limited to a few themes: lovers, flowers, a few musical cows and wandering clocks.... A light feeling radiates from bright country scenes: *Peasant Life*, a 'French' version of *I and the Village*. Chagall's contentment led him to paint his first great flower pictures with their bewitching colours. The portrait of *Ida at the Window*, which echoes the composition of *Window Overlooking Ile de Bréhat*, is filled with a glowing tenderness for its subject, his daughter Ida, while the *Double Portrait* and *Bella with a Carnation* give a mythical dimension to the eternal woman. After a long period of solitude, Chagall had found serenity and looked more openly on the classical masters.

Peasant Life (1925; above and details) is a reworking of *I and the Village* (1911–4). Chagall, who was at peace with himself, creates a cheerful and very 'French' composition, in which Russian motifs nevertheless come to the surface (he continued to work on *Dead Souls* until autumn 1925).

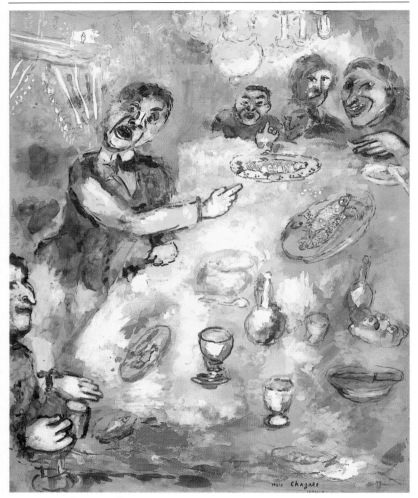

Painter and storyteller

During his forties, when he blossomed, Chagall was full of vitality and high spirits. Hardly had he completed the illustrations for *Dead Souls* in 1926 than he started to paint the preliminary gouaches for the *Fables* of La Fontaine, again commissioned

The Joker and the Fish (1927–8) is one of 100 gouaches for the *Fables*, which were exhibited in 1928 in Paris, Brussels and Berlin…and all sold.

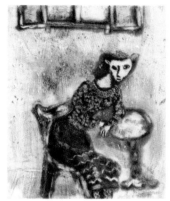

by Vollard, on which he worked for five years. Vollard responded to the chilly reservations expressed by Georges Rouault, who questioned him on his choice of a Russian artist to illustrate this monument of French culture, in this way: 'All that is specifically eastern in the sources of this author of fables [Aesop] has led me to think that an artist whose origins are such that the glamorous East seems familiar and natural is better equipped than anyone to render it in appropriate visual form…his aesthetic sense seems to me quite close and in a way related to that of La Fontaine, being at the same time naive and subtle, realistic and fantastic.' This statement caused quite a stir; its reverberations reached as far as the Chamber of Deputies.

Chagall initially 'thought' in colours, producing more than a hundred dazzling gouaches of these alexandrines in two years. He had been familiar with the Russian version by Ivan Krylov since his school days. But how could he render on copper the complex play of materials, the violence of the colours and the sharpness of the physical appearance? Chagall transcribed between 1928 and 1931 each of the illustrations himself, using various techniques – not only drypoint, hatching and cross-hatching but also painting, varnish and gouache. Thanks to the collaboration of numerous assistants placed under the direction of the line-engraver

The *Fables* illustrated by Chagall for Ambroise Vollard were not published until 1952 by Tériade (above). Above left: *The Cat Transformed into a Woman.* Below: *The Wolf and the Lamb.* Following pages: *The Satyr and the Wanderer* and *The Miller, his Son and the Donkey.*

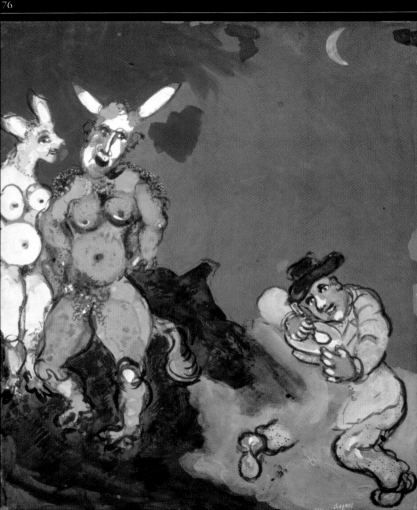

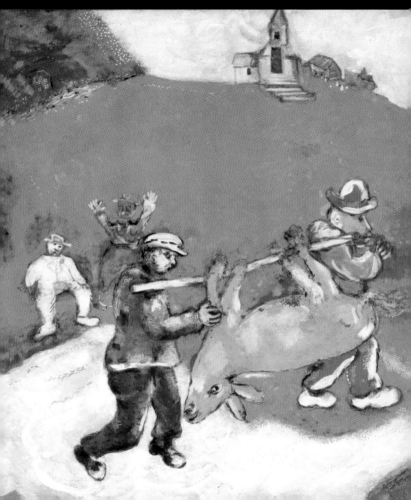

Maurice Potin, the black-and-white-plates appear in the end to be well and truly 'coloured' and show a disconcerting virtuosity. Subtle nuances in chiaroscuro spring from the rich use of hatching, an empirical and daring method that controlled the bite of the acid; on the dawn white paper the whole range of colour values appears, from ash grey to midnight black.

However, Chagall was not satisfied with the printing: each of the eight thousand five hundred pulls (!) of the *Fables* were eventually touched up in his own hand by brush, either in gouache or water-colour. Vollard, who had by then guaranteed the painter a regular income, was entirely won over.

He commissioned from the young co-founder of the Association of Painter-Engravers a new series of plates on the theme of the circus.

A passion for the circus

During his childhood, Chagall had seen many jugglers and had taken part every year in the carnival-like celebrations for the Jewish festival of Purim. He was fascinated by the circus, by the world of jesters that had arrived from Byzantium in the 10th century. Ambroise Vollard, a sardonic and

sentimental giant and a connoisseur of rare perception, invited the painter and his family to join him in his box at the Cirque d'Hiver. Chagall was filled with enthusiasm and produced, under the title *Cirque Vollard*, nineteen gouaches that capture the magical world of the circus – riders and clowns – through his genius for caricature. Acrobats and jugglers, magicians and imaginary animals (*The Smoking Goat*) are all part of the sense of wonder belonging to innocence rediscovered.

The circus had provided subject matter for a variety of different artists, including Degas and Toulouse-Lautrec, who had both drawn inspiration from the Cirque Fernando during the 1880s. Before, during and after the Depression of the 1930s, artists as famous and diverse as Picasso, Rouault, Bonnard and the austere Mondrian flocked to the circus as enthusiastically as to the Ballets Russes, before finishing the evening at the 'Boeuf sur le Toit'.

In these gouaches, as in the canvases related to them, Chagall allows his propensity for farce to run riot. Though he came close to a Lewis Carroll, he admired Charlie Chaplin most of all, writing of him in *L'Art vivant* in 1927: 'He is searching in the cinema for what I am attempting in painting.'

In 1928 Chagall, together with Bakst, who also lived in Paris, received his friends from the Jewish Theatre in Moscow, Solomon Mikhoels and Itzhak Feffer (below), who were on tour in the French capital. The Cirque d'Hiver (above) provided the inspiration for his gouaches in the *Cirque Vollard* series published by Tériade in 1952. Opposite: views of the circus (1925–7).

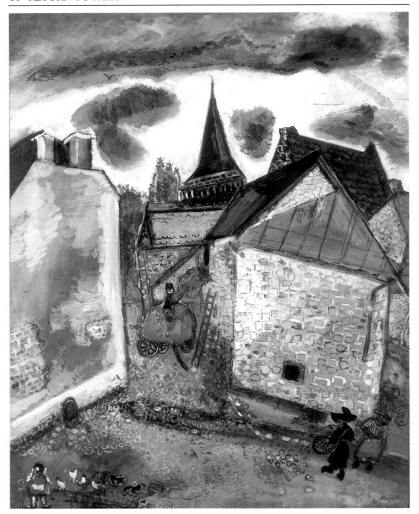

Discovering France

Chagall was very prolific: in addition to his paintings, he produced over four hundred engravings in fifteen years, claiming: 'I never complete a picture or an engraving without asking Bella for her yes or her no.'

In 1926 Chagall painted the church on the shores of Lake Chambon in the Auvergne on the spot.

Fondé à Besançon en 1795

à Paris depuis 1863

BERNHEIM · JEUNE & C^IE

SOCIÉTÉ ANONYME AU CAPITAL DE 756.000 F.

EDITEURS

His work did not, however, stop him from travelling, and, during 1926 and 1927, he spent long periods away from Paris. On his first visit to the Côte d'Azur, where he settled permanently nearly thirty years later, he was carried away by the brilliance of the light and by the magnificence of the flowers that Bella brought back from the market every day: *Lovers under Lilies*, *The Wedding Bouquet*. In the Auvergne, on the shores of Lake Chambon, in the Puy-de-Dôme, which the painter and sculptor Jean Dubuffet visited twenty years later, he painted numerous landscapes capturing the solemn spire of a church tower or the chalky whiteness of a farm wall.

From each of these periods spent in the country, including the snow-capped peaks of the Haute-Savoie, Chagall created fresh and spontaneous gouaches of a farmyard scene or the heat during the harvest – drawing on recollections of his own rural childhood in Russia – that evoke his affection for his adopted land.

'Chagall, the glory of the heart' (Lionello Venturi)

In Paris Chagall, who was naturally sociable and cheerful, mixed above all with writers – Jean Paulhan, André Malraux, Jules Supervielle, Georges Duthuit and Henri Michaux. However, he also met many artists – Georges Rouault, Pierre Bonnard, Maurice Vlaminck, Pablo Gargallo, who did his portrait in wrought iron, and the architect Pierre Chareau.... He was not on friendly terms with Picasso, Léger or the Surrealists.

At the Bernheim-Jeune Gallery, where he exhibited the gouaches of the *Fables*, Chagall met André Malraux (top) and Jean Paulhan (above).

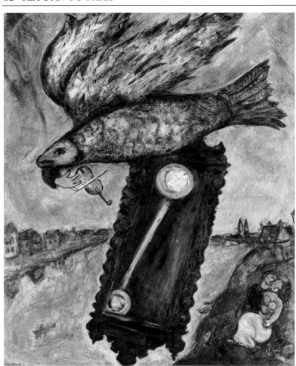

Time is a River without Banks, also known as *Time has no Banks* (1930–9; left) – a rather obscure title taken from Ovid – shows how Chagall borrowed the technique from the Surrealists, such as Max Ernst or René Magritte, of placing poetic images in unexpected juxta-positions. The winged fish, the flying clock, the gently flowing river and the intertwined lovers had by now become recurrent themes in Chagall's work. Below: Chagall and Bella on the *Champollion*, on which they sailed to Palestine, and the interior of Villa Montmorency in Auteuil.

In 1927 Chagall signed a contract with the Bernheim-Jeune Gallery. There were numerous articles about him by the most influential contemporary critics: André Salmon – who wrote the first monograph on Chagall in French in 1928, Christian Zervos, Philippe Soupault, Waldemar George, Maurice Raynal, Jacques Guenne, André Levinson and Georges Charensol. The Chagalls were a close couple, relaxed, in demand. They settled at the Villa Montmorency in Auteuil, one of the most beautiful neighbourhoods in Paris.

Chagall's discovery of the French countryside from 1928 to 1931 influenced his painting and his attitude to colour. His canvases of this period are marked by contrasting colours and a freedom of composition, while the subject matter ranges from lovers and

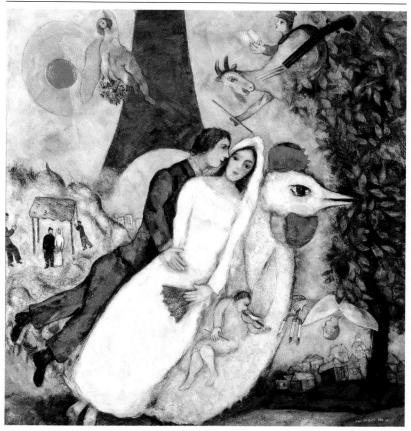

animals (*On the Rooster*) and flowers. Chagall deliberately returned to illogical juxtapositions: winged fishes, flying clocks, floating couples (*Time is a River without Banks, Angel with Flowers, The Bridal Couple at the Eiffel Tower*), in which top and bottom are inverted, the proportions jar and conflicting motifs merge to give the whole composition tension. These paintings are characterized by playful invention, fantasy images and poetic symbolism. The painter, who was at the height of his fame, was a leading figure in the School of Paris.

The title of *The Bridal Couple at the Eiffel Tower* (above) comes from Cocteau. The cockerel carrying the lovers (the flight towards the garden of Eden), the sun (the light-freedom of Paris) are painted in soft, sensuous brushstrokes, emphasizing the work's poetic symbolism.

Journey to Palestine

The main project of the 1930s, the illustrations for *The Bible*, was another commission from Vollard. This important series, consisting of over one hundred plates, occupied the artist from 1931 until 1939, and then from 1952 to 1956. It undoubtedly shows Chagall at the height of his powers. Indeed, its richness and universal spirituality had an effect on the rest of his work.

Before beginning what he sensed would be a solemn task, Chagall travelled with his family to Palestine to discover the land of his ancestors, 'to see and live his Bible'. After brief stops in 1931 in Alexandria and then Cairo, which, strangely, left no mark on him, he was welcomed by one of the pioneers of Israel, Meir Dizengoff, the founder and mayor of Tel Aviv. Between February and April 1931, he stayed in the Holy Land, which was then a British protectorate. Tel Aviv, Jerusalem and Safed were the main stopping places on this pilgrimage to his origins, which made, as he himself said, the strongest impression of his life. The very walls of Jerusalem echo with the memory of its historical and religious associations. The desert climate and the transparency of the winter light conferred on the holy places a truly staggering feeling of silent but peopled grandeur.

Ignoring the picturesque, Chagall went deep into the land of Judah, of which he had been dreaming since childhood. The synagogues, *The Wailing Wall*, *Rachel's Tomb*, painted from life, were

This gouache for *The Bible* series, *The Rainbow, Sign of Covenant between God and the World* (1931; below) reflects the sombre range of colours found in Chagall's paintings on his return from Palestine. Below: the tomb of Rachel, also painted by Chagall.

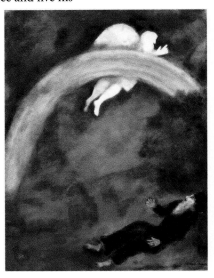

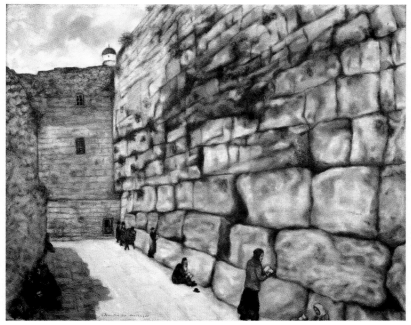

not so much 'documents' as the supreme expression of his renewed poetic and religious faith.

On his return to Paris, Chagall immediately painted some preliminary gouaches for *The Bible*. He used these as the basis for his etchings, increasingly employing a paintbrush to emphasize the painterly quality of the plates. His aim was to deliver the Biblical message of the Old Testament through his graphic technique and he worked hard on the choice of iconography from Genesis and the story of Abraham right up to the Prophets. The numerous stages of copper plates bear witness to the seriousness of the project for him and the inspiration he derived from the dazzling land of Israel. In the opening pages, the painter endows Ruth, Rachel, Esther, Sarah, the heroines of the Creation, with delicate or powerful charms and increases their original beauty. Yet other pages for the Bible are full of solemnness, reflecting

In Jerusalem, Chagall discovered the land of his ancestors. *The Wailing Wall* (1932; top), a 'painting-document' which Chagall began at the site, evoked the legendary ruin of Solomon's temple and expressed the charged emotion of holy places.

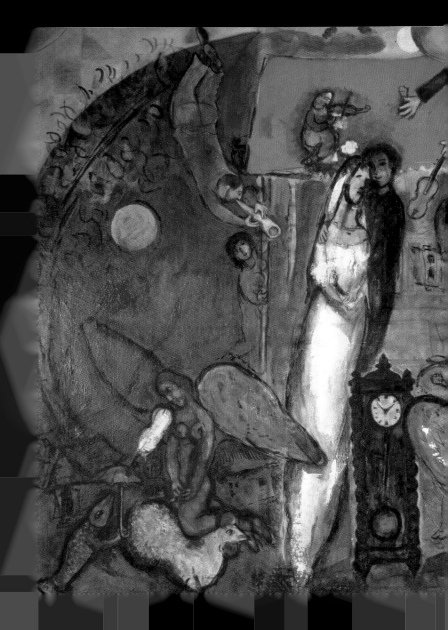

the painful events that gripped the whole of Europe as Hitler stepped up his persecution of the Jews. The faces of Daniel and Jonah presage the cataclysm in the night. The Prophets Nehemiah, Joel, Amos and Zachariah announce times of darkness before the universal light of the Jewish seven-branched candlestick returns to brighten the world again.

The era of persecution

During the 1930s the Chagalls travelled extensively. Chagall immersed himself in classical painting, visiting Holland to see Rembrandt, Italy for Caravaggio and Tintoretto, and Spain for El Greco and Goya. On each trip the work of different artists filled him with new ideas before he returned to his own imagination for inspiration. In 1933, however, three of his works were burnt by the Nazis in Mannheim. Some of his canvases on public display in German museums were removed and even sold at an extremely low prices, while others were held up as examples of *Entartete Kunst* (Degenerate Art) in an exhibition held in Munich in 1937. On his trip to Poland in 1935 for the opening of the Jewish Institute in Vilnius, Chagall was profoundly shocked by the ghetto, the widespread anti-Semitism and the sound of marching boots, a sign of the impending massacres and deportations. The rare news he received from Russia, then under the yoke of Stalinism, underlined the tragic failure of the Bolshevik Revolution as intended by Lenin, whom the painter denounced in

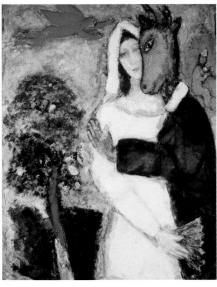

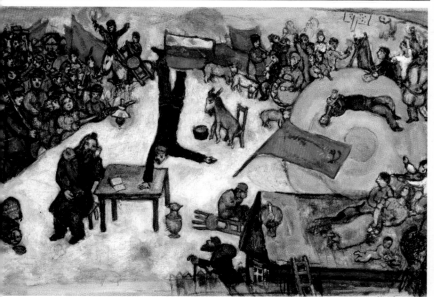

his painting *The Revolution* of 1937. The atrocities of the Spanish Civil War, 'Kristallnacht' in Germany, the annexation of Austria and the Sudetenland could only mean something tragic.

Chagall, a French citizen

In 1937 Chagall moved near to the Trocadéro. The Popular Front granted him French nationality and the International Exhibition paid him even greater tribute by including seventeen of his works in one room, many more than those of his contemporaries Giorgio de Chirico, Marcel Gromaire, Moïse Kisling, Chaïm Soutine and Amedeo Modigliani.

In his new studio, *Flowers* and *Cello Players* covered the walls, opposite *A Midsummer Night's Dream*, like so many joyful, incantatory images in the face of tragedy. Nevertheless, Chagall also undertook powerful and dramatic compositions, such as *White Crucifixion* (1938). This visionary ex-voto extends beyond its initial Christian significance. All the details surrounding the central crucified figure illustrate the

In 1937 the Nazis organized an exhibition of 'Degenerate Art' in Munich (opposite above). Chagall was represented by three works – all removed from German museums – including *The Pinch of Snuff. To My Wife* (1933; pages 86–7) and *A Midsummer Night's Dream* (1939; opposite) are poetic odes proclaiming his love for an immortalized Bella. *The Revolution* (1937; above) has political overtones. It denounces Lenin, portraying him as a clown, and shows a red flag to the Revolutionaries.

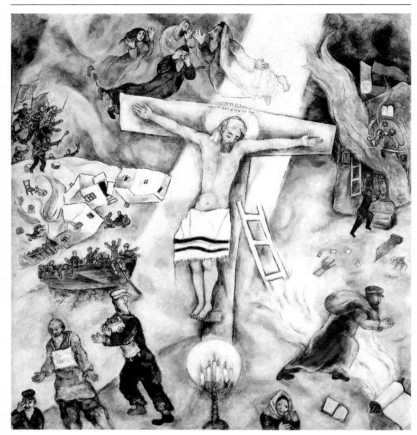

way in which the Jews had been ostracized. The identification of the martyr with Jesus of Nazareth, who was himself a Jew, allows us to view the timeless incarnation of mercy. The sacrifice of a man, who in this painting is not the son of God, symbolizes the whole of humanity in its struggle against evil.

The second exile

In 1939, shortly after the accidental death of Ambroise Vollard and their exodus to Touraine, the Chagalls left for what was to become Vichy France. Advised by

The Christian philosopher Jacques Maritain and his wife Raïssa, a Jew converted to Catholicism, were close friends of the painter from the 1920s, first in Paris and then in New York (opposite, Chagall in New York).

André Lhote, they bought a former schoolhouse in Gordes in the Lubéron, where they spent a year from 1940 to 1941. After some last-minute hesitation, the Chagalls finally decided to leave France when the anti-Semitic laws were promulgated by the Vichy government. It was only through the courageous intervention of Varian Fry, a director of the American Aid Committee, and Henry Bingham, the American Consul in Marseilles, that they managed to escape Pétain's police. The committee had been set up to offer, at the invitation of the Museum of Modern Art (MOMA) in New York, a refuge to artists living in the south of France: Matisse, Picasso, Masson, Ernst.... Helped by their daughter Ida, the Chagalls arrived in Lisbon with 1600 kilos of luggage containing all the works of art the Nazis wished to confiscate. On 23 June 1941, the day after Germany invaded Russia, the torch of the Statue of Liberty blazed before the eyes of an emotional Marc and Bella Chagall.

'In order to find only suffering and tears, we must turn to the Christ Chagall painted in the centre of a picture of pogroms, a Christ stretched across a lost world, in a great expanse of ivory. The Jewish candlestick is at his feet. In the sky a group of Jews are lamenting. Misery with no solution. The synagogues are burning, the Jews fleeing to the four corners of the earth. Only the compassion of the crucified Christ shines forth and draws their suffering towards him. The suffering solemnity of the Jews here merges with the tender solemnity of the French primitives.'

Raïssa Maritain
Chagall ou l'orage enchanté, 1948

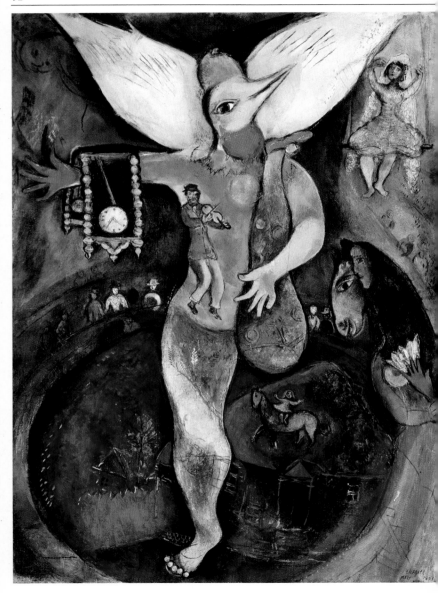

At first, the Chagalls were bowled over by New York, whose cheerful vitality was so different from the war-torn Continent of the 1940s. The metallic reflections of the skyscrapers, the wind whistling through the grid pattern of the streets, the rule of money, the cars, in short, the frenetic life of this cosmopolitan city made a huge impression on them. Yet Chagall refused to learn English and kept on speaking Yiddish, Russian and French.

CHAPTER 3

FROM EXILE IN AMERICA TO HOME IN PROVENCE

In New York, Chagall initially lived in several hotels, where he found it difficult to work. In 1943 he moved to 74th Street and painted this *Juggler* (opposite), an enigmatic and flamboyantly coloured cockerel acrobat dancing in a circus ring in which a Russian village is reflected.

During the war, the immigration laws in the United States were tightened. The Chagalls were welcomed, nevertheless, as Russia was now an ally in the war against Germany.

A European in New York

New York had not yet become the Big Apple, but among the many refugees sheltering in the shadow of the Statue of Liberty were artists and intellectuals (particularly French), who had managed to flee Marshal Pétain's regime: André Breton, Claude Lévi-Strauss, Jacques and Raïssa Maritain, Max Ernst, Yves Tanguy, Fernand Léger, André Masson, Jean Hélion, Ossip Zadkine…. Near Fifth Avenue, collectors (Peggy Guggenheim, Hilla Rebay, Louis Stern), museum curators (Alfred Barr, James Johnson Sweeney, René d'Harnoncourt) and artists (Alexander Calder, Stanley W. Hayter) were happy to welcome these representatives of modernity. Numerous exhibitions testify to the thirst for European culture: 'Art in Exile' at MOMA and 'Artists in Exile' at the Pierre Matisse Gallery in 1942, 'European Artists in America' at the Whitney Museum in 1945. Pierre

Artists
in
Exile

MARCH 3 TO 28, 1942

PIERRE MATISSE
41 EAST 57th ST., NEW YORK

Artists in exile in New York (below): front, Matta, Zadkine, Tanguy, Ernst, Chagall and Léger; back, Breton, Mondrian, Masson, Ozenfant, Lipchitz, Tchelitchev, Seligmann and Berman.

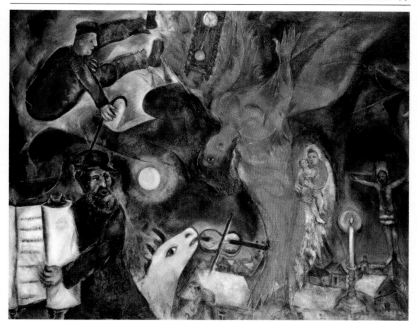

Matisse represented Chagall in America for more than forty years. In 1946 a retrospective of the exiled painter's complete work was organized by Sweeney at MOMA; it was Chagall's second – the first was held at the Kunsthalle in Basel in 1933.

Unlike many of his companions in adversity, Chagall had managed to leave France with some currency and, more importantly, thanks to his daughter, with most of his paintings – something that was essential to a man who still mourned the loss of his works in 1914. In his first apartment, facing the Hudson River, Chagall unpacked his pictures. Many were unfinished and completed on American soil. The first canvases to be finished in the United States were in keeping with the style of the paintings conceived in France, though the colours were more powerful and intense.

Top: *The Falling Angel.* The photograph (above) shows Bella and Marc Chagall in Pierre Matisse's gallery.

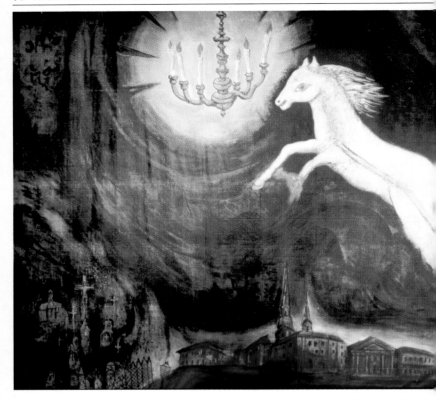

Chagall and the ballet: *Aleko* and *The Firebird*

In spring 1942, the choreographer Léonide Massine,
a former dancer in the Ballets Russes, asked Chagall
to design for the New York Ballet Theater, America's
première dance company, the sets and costumes for
Tchaikovsky's ballet *Aleko*, inspired by Pushkin's poem
The Gypsies. The first night was held in Mexico City
in September that year and was a triumph.

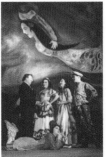

Massine, a worthy successor to Nijinsky in
Diaghelev's company, brought an entirely new
theatrical element into classical dance. Marc and Bella,
who was passionate about the theatre, formed a warm
friendship with their compatriot, which was

For the music of *Aleko*, a ballet in four acts with four backdrops, Chagall and Massine chose Tchaikovsky's *Piano Trio*. Act I: 'Aleko and Zemphira by Moonlight' (opposite bottom); Act II: 'The Carnival'; Act III: 'A Wheatfield on a Summer's Afternoon'; Act IV: 'A Fantasy of St Petersburg' (above left). The painting is a double homage: not only to St Petersburg, painted in flamboyant red, but also to the memory of Pushkin, author of the poems *The Gypsies* and *The Bronze Horseman*. On the left, the tomb of Zemphira, the heroine, is lit by the burning candelabra towards which a white horse with a chariot is flying.

Above: the Chagalls in New York.

strengthened by a shared feeling for the Pan-Slavic movement. Every day they worked together around a gramophone, a palette and...a bowl of bortsch, rediscovering their common roots while discussing musical scores, gouaches and traditions.

Aleko is the very archetype of the sombre hero of Russian Romantic literature who is driven by passion and jealousy to murder and despair. The painter succeeded in rendering this sublime and provocative pathos. The four gigantic backdrops painted by Chagall accentuate the peculiarly Russian art of the plot. Rather than 'sets', in the true sense, they are monumental evocations of Pushkin's Russia in front of which the dancers move.

Chagall made a name for himself in New York with his enchanting sets, costumes and masks for *The Firebird* (this page and opposite).

• Balanchine blew in and out of the costume studio, as did the New York City Ballet's principal dancers, Maria Tallchief and Francisco Moncion ...Ida was following in the footsteps of her mother, who had supervised the costumes of the ballet *Aleko*. After

Under the cold light of the high plateaux of the Anahuac, Chagall exaggerated the colour, covering the curtains as the still grandeur of the American space would do. The theatrical virtuosity of Massine's choreography set off the costumes painted in the vivid colours of Russia.

Chagall won great acclaim for his designs for both *Aleko* and, in 1945, Stravinsky's ballet *The Firebird*, which was commissioned by George Balanchine, the founder of the New York City Ballet. In this work, Sirine, the bird of paradise, a symbol of happiness

Ida had dressed the dancers, Marc came to inspect them; sometimes he took a brushful of aniline colour and dabbed it directly onto their costumes, breaking up a line here and there, flicking a few dots or heightening a tone. •
 Virginia Haggard, *My Life with Chagall*, 1986

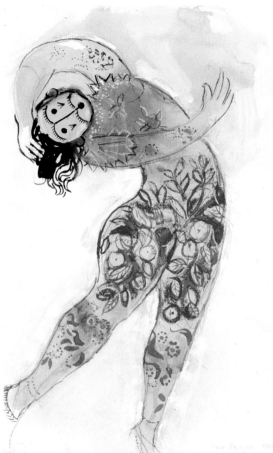

A few months after their arrival in New York, the Chagalls began to miss France. They kept a limited circle of European friends and saw very few Americans. Pierre Matisse sold principally to Jewish or pro-Jewish collectors, and the New York popular press was critical of the seven exhibitions he held in his gallery up to 1948. Paradoxically, the years in exile distanced the painter from French culture, and he rediscovered his Jewish roots from his Yiddish-speaking friends: the writer Meyer Schapiro, the sculptor Chaïm Gross (who made five portraits of Chagall), the Yiddish writer Joseph Opotashu and the art historian Lionello Venturi.

familiar from Moscovite legends and traditional *loubki* prints, is glorified. The curtain and three sets were not to the taste of the composer, Igor Stravinsky, who found them not sufficiently 'modern' and preferred the radicalism of an artist like Picasso. Nevertheless, the aristocrat – and dandy? – of contemporary music paid homage to the painter's daughter Ida, who was responsible for making the eighty dazzling costumes designed by her father, using collage and patchwork.

From the war to Shoah: 'The last Prophets are mute…' (Chagall, 1942)

In 1943 the news arriving from the Russian front was tragic. For Chagall, who had met former friends from Moscow in New York, the memories came flooding to the surface. The numerous *Crucifixions* he painted at this time symbolize the martyrdom of his country. Fire, persecution and death stand as dramatic witnesses around the *Yellow Crucifixion*. The suffering that emanates from the paintings on war is expressed in metaphors (either experienced or dreamed): burning villages, a shipwreck in a storm, a rooster crowing in the bluish mist of the night, a red donkey with crazy legs.

The atrocities at the battlefield were, however, surpassed by the horror of the Holocaust. Overwhelmed, Chagall was never able to paint Shoah. In the face of this unspeakable apocalypse, he could only transmit his feeling through angry silence and silent tears.

The death of Bella: 'For years, her love influenced my painting'

During their exile in New York, the Chagalls loved to escape into the countryside, as they had done in Paris. From 1943, they found a pleasant retreat with a studio at Cranberry Lake, in the nearby Adirondack Mountains. It was here that on 25 August 1944 they heard of the liberation of Paris on the radio. Bella was looking forward to returning there as soon

This study for *The Revolution* (1937) corroborates the words of Meyer Schapiro, a friend of the painter and an unrivalled medievalist: 'Medieval art is simply illustration – the illustration of a sacred legend. In this sense, Chagall is indeed the greatest of all the illustrators.'

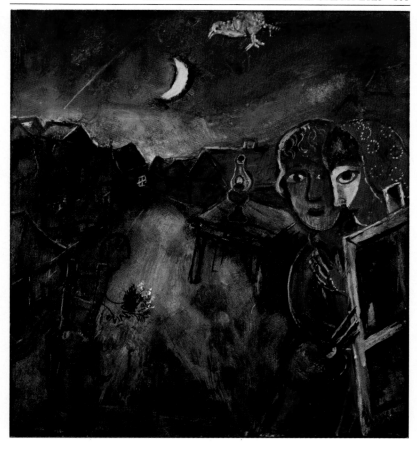

as possible, but it was not to be: a few days later, she died in a nearby hospital following an ill-treated infection. On 2 September 1944 Marc Chagall suddenly lost the woman who had been his muse and companion for over thirty years: 'Everything turned black before my eyes.' Totally demoralized, Chagall did not pick up a paintbrush for nine months.

In spring 1945 he cut up an earlier canvas, *The Harlequins*, and made two iconic images from it in homage to his beloved: *Wedding Lights* and *Around*

Cranberry Lake (1943) forms part of a series of canvases in which Chagall, seen here at his easel, expressed his solitude and the nightmare of the Nazi persecution of the Jews.

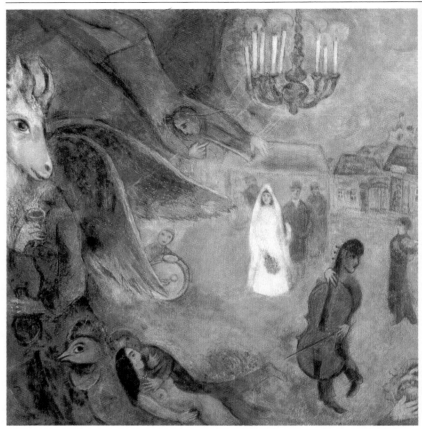

Her, which are like a pictorial echo of the two lengthy and fine autobiographical texts that Bella had written shortly before her death: *Lumières allumées* (*Burning Lights*) and *Première Rencontre* (*First Encounter*). These reminiscences of her youth in Vitebsk were initially published in Yiddish in New York in 1947, with a postscript and illustrations by Chagall, then in French, translated by Ida, in 1973. Early in 1946 Chagall bought a small traditional house in the wooded slopes of the Catskills in the north of New York State. He spent the last two years of his stay in America

Wedding Lights (1945; above) is a pictorial metaphor of the lament which Chagall inscribed as a postscript to Bella's book: 'Basinka, Bellotschka of the mountain, to Vitebsk, who is reflected in the Dvina with the clouds, the trees and the houses.'

Pour ta
papa →

Marc Chagall
1946-1947
N.Y.

Chagall dedicated a copy of the French edition of *Burning Lights* (below, the first edition in Yiddish) to his daughter (1973; left). Bottom: a lithograph for *Arabian Nights*.

working in this new refuge, where he would not be reminded of his life with Bella.

A Persian symphony: *Arabian Nights*

There he began the enchanting cycle of preliminary gouaches for the illustrations of The Thousand and One Nights – *Arabian Nights* – which Vollard (yet again!) had already discussed with him twenty years earlier. This commission from the New York publisher Kurt Wolff marked the painter's first encounter with the technique of colour lithography.

Thirteen lithographs dripping with oriental jewels and flowing with 'supernatural' rhythms, as the poet Apollinaire would have said, came off the press: the magnificent Sheherazade and her sister Dinarzade, who sing in an ingenuous and princely fashion, before Sultan Shahriyar, the feline modesty of Kamar al-Zaman and the illusions of the

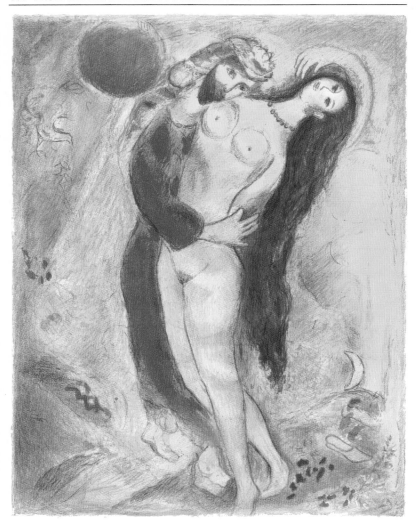

dervish.... The fluidity of the ink and gouache illustrations and the richness of the compositions add a special dimension to the mischievous and playful atmosphere of these ancient Arabian tales.

Jacques Schiffrin invited Chagall to produce the lithographs for *Arabian Nights*.

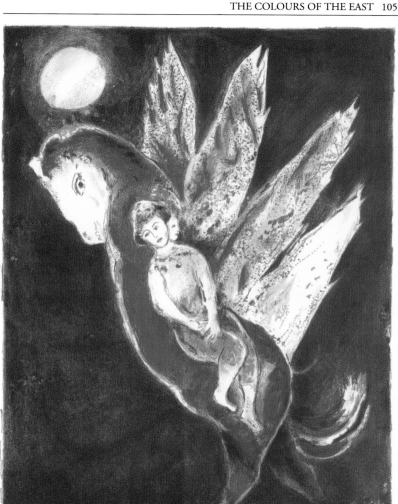

Chagall's return to France marked the beginning of a particularly creative and fertile period in which he produced – with the help of Charles Mourlot and his friend Charles Sorlier – numerous colour lithographs,

The sensuousness of these images testifies to the artist's encounter with Virginia.

including the celebrated pages of the journal *Derrière le miroir* (Behind the Mirror), published by his dealer in Europe, Aimé Maeght.

The return to France: Marc and Virginia in Orgeval

In 1945 Ida introduced her father to a young woman, Virginia Haggard, who came from Quebec in Canada. She had studied at the Ecole des Beaux-Arts in Paris, before marrying an Irish-born painter, John McNeil, by whom she had a daughter.

She moved in with Chagall and in 1947 gave birth to a son, who was called David. After a brief stay in Paris, Chagall decided to return to France for good with Virginia and David. Ida had found for them a charming manor house situated in Orgeval, near Saint-Germain-en-Laye, a few kilometres west of Paris. It was built of wood in the modern style: with its two pointed turrets and rocaille balconies, it looked as though it had come from a children's storybook. Marc and Virginia remained there for over a year.

In the paintings of this period tender lovers sink into each other's arms in the pale dawn light with the familiar and appealing witnesses to this union: indigo violin, almond cow, emerald rooster, reseda moon. In October 1947 the first retrospective of Chagall's work in France, organized by the curator Jean Cassou, was held at the Musée National d'Art Moderne in the Palais de Tokyo in Paris.

In 1948 Chagall and Virginia went to live at Orgeval with David (below, with Chagall) in 'a fantastic chalet-like house with gables and a rotting wooden turret. Marc chose two large light bedrooms for his studio.'

Virginia Haggard, *My Life with Chagall*, 1986

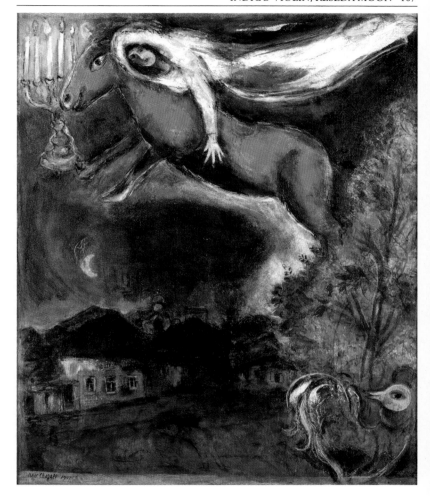

'Paris, reflection of my heart. I would like to melt into it, no longer be alone with myself'

The painter's attachment to France, his second homeland, was unshakeable. At sixty, he rediscovered the age-old beauty of the banks of the Seine. Numerous tributes were paid to him throughout Europe and, in

The solemn atmosphere of *Nocturne* (above) hints at Chagall's separation from Virginia. The bride on the flying horse still evokes Bella.

'Paris, of which I dreamed in America and which I have found enriched, alive again – it is as though it was necessary for me to be reborn, to dry my tears in order to cry once more. The absence was necessary, the war, the suffering so that all this could be reawakened in me and remain the framework of my thoughts and my life,' Chagall confessed to Jacques Lassaigne shortly after completing *Eiffel Tower* (1953; left). This anguished drawing in pastel – a technique rarely used by the artist – continued the *Homage to Paris* series.

Opposite: detail from a retrospective of the artist's work held in Brussels and Amsterdam from 1956 to 1957.

June 1948, he was awarded the engraving prize at the Venice Biennale.

To Chagall, who had been exiled twice, Paris represented first and foremost the city of hope. It was also the place where he had begun to establish himself and was tied up in his mind with his destiny as an artist. Chagall wanted to pay his own tribute to Paris and painted a series of twenty-nine pictures that were exhibited at the Galerie Maeght in 1954. Strange allegorical views of the banks of the Seine, the church of Saint-Germain-des-Prés, Notre-Dame, the Column of the Bastille…

in these lyrical and colourful compositions, arches of bridges and solar disks, fantastic birds and legendary minotaurs, floating couples and flowering bushes merge and vie with each other. Using notes taken down at random on walks and sketches reworked in the apartment on the Quai d'Anjou, Chagall celebrated the city, allowing his dream to be discerned through a metamorphosed poetic reality. The Parisian buildings and the ripples of the Seine gradually replaced the roofs of Vitebsk and the sluggish waters of the Dvina. Chagall transformed these archetypes

A fter leaving London, Valentina Brodsky (Vava) bought an apartment on the Quai d'Anjou (above). The painter's love of water is found in many of his canvases: the Dvina, Lake Chambon, the Seine, the Hudson, Cranberry Lake, the

into allegories. His world is full of lovers, angels and clowns, roosters and fish, a symphony of carefully conducted tones, brushes and flowers here, palettes and fruit there.

Mediterranean. After their marriage, the sitting room became Chagall's studio.

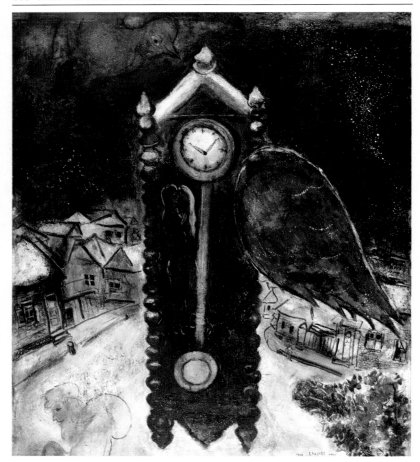

The Mediterranean years: the light in Vence

In fact, it was the south of France, rather than Paris, that really caught Chagall's imagination from 1950 onwards. At the suggestion of Tériade, the publisher of *Verve* who printed various works that Vollard had left behind, Chagall bought in 1950 a high ochre building in the hinterland of Nice, near the medieval fortifications of Vence. Called Les Collines, it included

'His colour helps us to judge his power to take things back to the Garden of Eden, to re-create paradise lost with his brush, while leaving everything drifting in the stirrings of the imagination.'
Christian Zervos, 1939

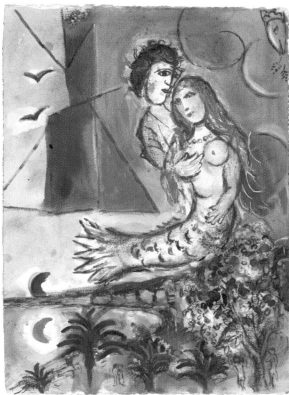

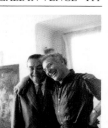

a vast studio overlooking the sea and had provided inspiration many years earlier for the writer Paul Valéry in his secret affair with Catherine Pozzi-Bourdet.

It was here that Chagall, whose feelings for Virginia were cooling, celebrated the marriage of his daughter Ida to Franz Meyer in January 1952. At the time this young Swiss museologist, who later had a high reputation, was about to begin his monumental monograph on Chagall. Published ten years later, it is still in every way a model of writing and analysis, an essential reference book. From then on, Chagall tended to work at Les Collines in the company of the woman who became his ally and muse for thirty-three years: Vava.

After the Second World War, Tériade (top), who came to Paris from Greece in 1915, was able to publish the engravings belonging to Vollard's estate. On his advice, Chagall bought 'Les Collines' in Vence (above). *The Siren and the Poet* (1960; above left) evokes the marriage of his daughter to Franz Meyer (below).

Opposite: *Clock with a Blue Wing.*

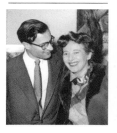

'I see only you, who lives only for me' (Chagall's poem to Valentina Brodsky)

In spring 1952 Chagall met Valentina Brodsky at the home of Tériade, who had settled in Saint-Jean-Cap-Ferrat. He immediately fell under the spell of her unique and cultured personality. Born in 1905 in Kiev (where her family owned a large sugar business), she had left the Ukraine during the Revolution via Odessa then Rome, before completing her studies at a Russian school in Berlin. 'Vava', as she was known, who had married an Englishman in 1938, had then lived in London. Her divorce was granted after the war and she settled in Paris close to her brother, who had himself known Bella and Marc Chagall before the German Occupation....

Chagall always refused commissions for portraits, including the one from Léon Bakst in 1914. However, Bella, Ida and then Vava (above) were all immortalized by his brush. Charmed by the calm beauty of his new companion, Chagall derived inspiration from her for the last thirty years of his life. Begun in Vence in 1953 but not completed until 1956, this first portrait of Vava (left) expresses the rejuvenating effect of her love on Chagall. The brown and blackish-brown monochromes, the powerful amaranthine red, the sumptuousness of the bouquet with its golden yellow, red and ivory petals highlight the beauty of this oval face. Like Rembrandt, whose self-portraits and portraits of Saskia Chagall greatly admired, Chagall painted many portraits of himself and of his muses.

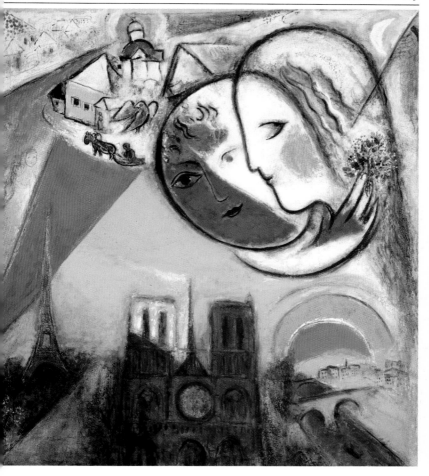

On 12 July Marc and Vava were quietly married at Clairefontaine, near Rambouillet, at the home of Claude Bourdet, chief editor of the journal *Combat*, and his Russian wife Ida.

The mature painter, who lived happily in his Mediterranean home, found fulfilment in this marriage.

Sunday forms part of the romantic cycle inspired by Vava. Idealized as the sun, the lovers from Russia share a moment of tenderness in front of the monuments of Paris.

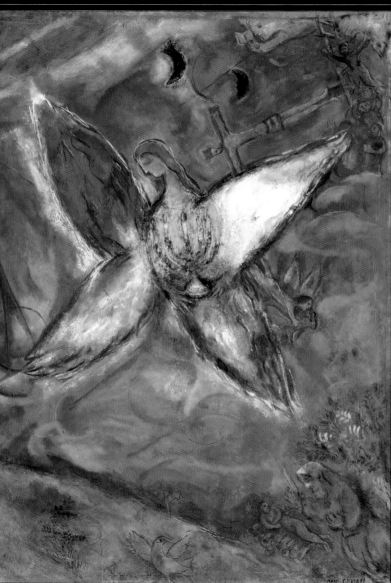

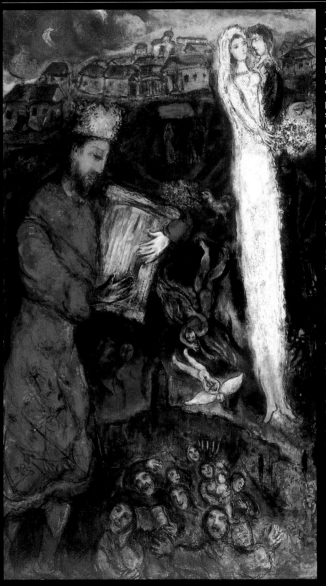

In a dazzling symphony of carmines and vermillions (left), the artist identifies himself in his mature years with David, the prophet-king, the second sovereign of Israel. With his unique narrative ability, he mixes past and present in a vibrant kaleidoscope, Vitebsk above, Vence below, the memory of Bella and his marriage to Vava. It is David, the poet-king, the great author of the Psalms, the musician-king, the one who sang for Saul, and not the shining hero, the conqueror of Goliath, that the painter immortalizes here, singing before the Jewish people gathered at his feet. Abigail and Ahinoam, his two successive wives, like Bella and Vava, are present, one beneath the traditional red wedding canopy in Vitebsk, the other as a young bride adorned with a wedding bouquet by the artist's brush.

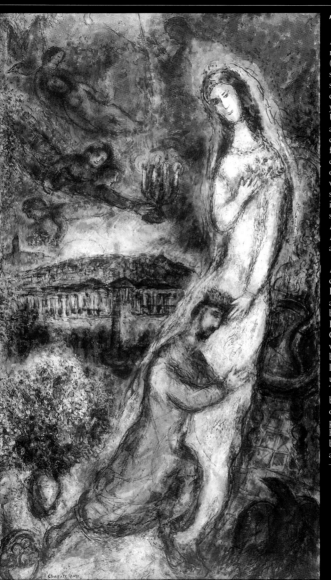

The two canvases depicting *David* (opposite, in red) and *Bathsheba* (left, in blue) are some of the most successful created during Chagall's years in Vence. Unusually, he accepted a commission in Paris for a great pictorial ensemble consisting of a large mosaic with greenery surrounding a patio, in front of five symbolic paintings: *David* and *Bathsheba, Dance* and *Music* and *View of Paris*. In *Bathsheba*, Chagall depicts a mature David, in love with a caring Bathsheba, before an imaginary Place de la Concorde; the whole picture is bathed in celestial light and has an unreal air about it. The woman who became the mother of Solomon is portrayed here in all her seductive charm by a passionate and ageing man.

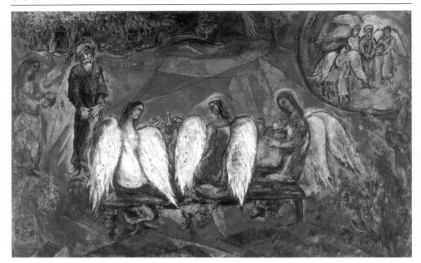

The chapel at Vence

On arriving in Vence, Chagall discovered a beautiful disused chapel, Notre-Dame du Calvaire, cruciform in plan and with good proportions. The painter instinctively wanted to restore the dilapidated building with its twelve walls to its original purpose as a place of worship by filling it with his own pictures of the Eternal Message. For many years, Chagall worked on a series of paintings known as the *Biblical Message*, which was unprecedented in its scope and daring. Twelve episodes were taken from Genesis and Exodus and five canvases illustrated The Song of Solomon.

Unfortunately, it was impossible to install them in the chapel as planned, but the series was donated by Marc and Vava Chagall to the city of Nice, where a museum dedicated to these works – the Musée National Message Biblique Marc Chagall – was opened in 1973 by André Malraux. This timeless message of love between people marks the pictorial, poetic and philosophical testament of Marc Chagall.

Discovering enamel

Ceramics have been part of the tradition of Provençal pottery since time immemorial. From 1950 Chagall took pleasure in experimenting with the art of the kiln in various workshops, firstly with Serge Ramel in Antibes, then in Vence and at Biot. He eventually met Georges and Suzanne Ramié, who closely advised the painter for ten years. In the 1950s the Ramiés enjoyed a legendary reputation throughout the south of France: in their ceramics studio in Vallauris it was possible to meet Picasso, who had settled nearby at 'La Galloise' with Françoise Gilot and their children Claude and Paloma; Henri Matisse also drove over regularly from the Hôtel Régina, on the hills at Cimiez, to oversee the production of his panels for the Chapel of the Rosary for the Dominicans in Vence.... Chagall, who lacked patience, was encouraged by his first attempts. He quickly mastered the ductility of the metallic oxides and the colours with which he decorated the traditionally shaped pieces, moulded or modelled to his orders. In ten years, over two hundred plates, plaques, wall panels and vases were illuminated with his favourite subjects, views of Paris, lovers, cockerels, fishes, Biblical subjects, the circus, La Fontaine's *Fables* – all

A braham and the Three Angels (opposite top) belongs to the *Biblical Message* series, the artist's magnum opus. The seventeen monumental canvases, including *Jacob's Dream* (pages 114–5), occupied Chagall – who found in the Bible the source of all poetry – for twenty years. The series, together with the mosaic *The Prophet Elijah* (1971; opposite centre), was bequeathed to the Musée National Message Biblique Marc Chagall in Nice. Like Picasso, Chagall discovered ceramics in Vence: *The Sun* (1951; left) and *The Promenade* (1961; above).

filtered through his rich imagination. His approach to enamelled clay was as sensuous as the work of Bonnard, Derain, Maillol or Rouault under the ceramicist Metthey fifty years earlier. In the past, Chagall had had the opportunity to admire their seductive creations in the gallery of their sponsor Ambroise Vollard in Paris and at the Pierre Matisse Gallery in New York. No doubt they aroused his curiosity.

Like a child with Plasticine, Chagall modelled with his hands strange baroque vases in the form of conches, ewers beautifully shaped like the female body.... He had no use for rules and, joking but fascinated, waited for the opening of the kilns.

In ceramics, such as *The Vision* (1962; left), as in stone, such as *King David* (marble, 1973; below), Chagall concentrated on his favourite themes. Familiar subjects are given fresh impetus and a poetic dimension through newly acquired techniques. Above: Chagall at work in the Madoura ceramics studio in Vallauris.

Experiments in stone

Continuing the art of ceramics, Chagall turned his hand to sculpture, mainly using a soft limestone, known as Rogne stone, which he sculpted in bas-relief. The deliberate lack of sophistication of the figures and fabulous animals set in stone recall wall paintings, or rather, Romanesque capitals (*Sculpture-column, Christ*).

It was extraordinary – even paradoxical – for this painter who used colour in such a striking way to work so rigidly in monochrome, white on white. Just as he had when experimenting with the technique of drypoint on copper plates, so he now found artistic freedom in this seemingly restrictive form. The use he made of the tools heightens the sense of spirituality and greatness, qualities

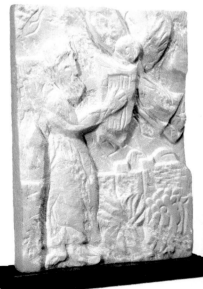

he had admired in the ancient statues seen on a trip to Greece. In the 1970s he completed several marble plaques (*King David*) before sculpting in the round. His last plaster casts added yet another facet to his talents.

Assy, in the name of freedom for all religions

At the age of seventy Chagall discovered the many possibilities offered by stained glass. The play of light and colour found in this technique, which had reached great heights during the Middle Ages, fired the painter's imagination.

His stained-glass windows reveal his deeply held faith. Chagall's first work in the medium was for the baptistery of Notre-Dame-de-Toute-Grâce at Assy, in the Haute-Savoie region, in 1956. The

Above left: *Woman-rooster* (marble, 1952). Below: *Fantastic Animal* (bronze, 1957).

'In the Chagallian form, whether it be woman, bird, donkey or fish, whether engraved, sculpted or painted, there is a game, a breath, a humour, a power which unite abstract and natural form at the same time.'
Charles Estienne, 1952

Overleaf: windows in Metz Cathedral.

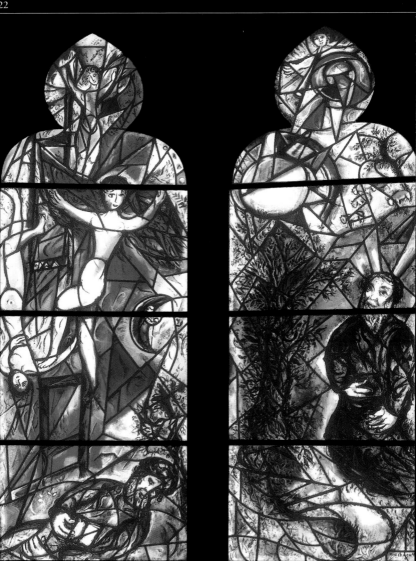

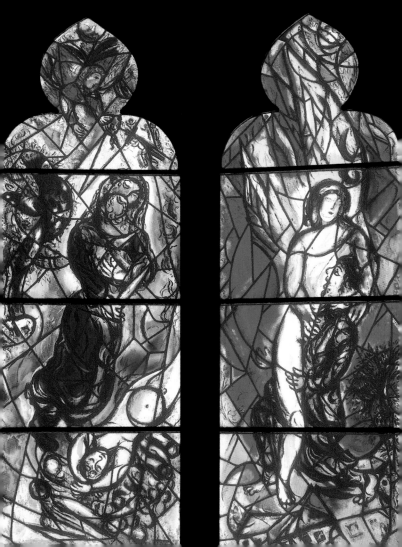

Dominican father Marie-Alain Couturier, a friend of
Jacques and Raïssa Maritain, Georges Braque and Le
Corbusier and a tireless revivalist of French religious
art, had commissioned Chagall to work alongside
Rouault, Léger, Braque, Jean Bazaine, Jean Lurçat,
Lipchitz and Germaine Richier, on the interior of
this intentionally modern church, conceived by the
architect Maurice Novarina. To help him, Chagall
brought out the studies sketched during a journey to
Chartres Cathedral in 1951, when he had been totally
dazzled by the rose windows. For Assy, he decorated the

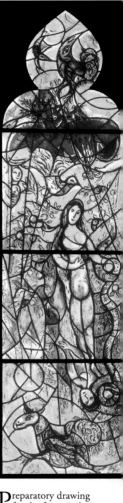

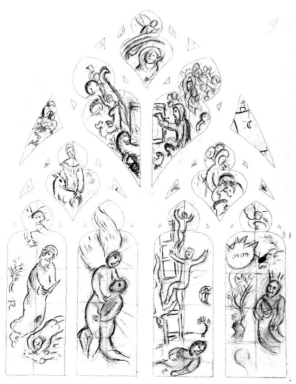

Preparatory drawing
for the first window
in the northern apse
of Metz Cathedral
(1958; left), *The
Patriarchs: Abraham,
Jacob* and *Moses*.

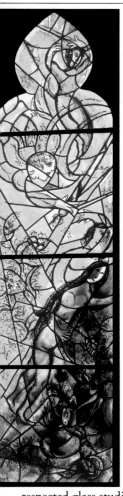

whole room with two high windows in grisaille, prepared from sketches in washdrawing, throwing light on a long ceramic panel, *The Crossing of the Red Sea*, dedicated 'in the name of freedom for all religions', and two marble bas-reliefs of the Psalms.

This first highly significant experiment was followed by many others, including commissions to design the stained glass for the cathedral of Saint-Étienne in Metz (1958) and the synagogue of the Hadassah University Medical Centre in Jerusalem (1960), which mark the summit of his achievement. Later examples – the Chapelle des Cordeliers in Sarrebourg (1975), the church of St Stephen at Mainz (1978) and the more modest, as well as the last, Chapelle du Saillant in Corrèze (1982) – were equally successful.

'A stained-glass window represents the transparent partition between my heart and the heart of the world'

Chagall was given a guiding hand with this new technique by two master glass makers of rare integrity, Charles Marq and his wife Brigitte Simon, who ran one of the oldest and most highly respected glass studios in France. Attentive, sensitive and loyal, they helped him for twenty-five years. Charles Macq rediscovered for him the ancient and forgotten medieval process of laminated glass, which guarantees the maximum diffusion of light, while also respecting variations in transparency or opacity as well as the strength or delicacy of the line.

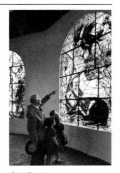

The immense stained-glass windows Chagall created, testimonies to his grace and talent, fill numerous places of worship with light, according to the seasons and the time of day. The windows of Metz Cathedral from 1964 – *Eve and the Serpent* (centre left) and *Adam and Eve Expelled from the Garden* (centre right) – showing themes from the *Biblical Message* came after the dozen windows created for the synagogue at the Hadassah University Medical Centre in Jerusalem (above, the yellow window: *Nephtali, the Tenth Son of Jacob*). In these Christian or Jewish places of worship, the faithful are bathed in grandeur and solemnity, strengthened by the iconography of the Book of Books, witnesses to a transcended vision of the love in humankind.

Over thirty years Chagall lit up fifteen locations with his exceptional windows, in Britain, France, Germany, Israel, Switzerland and the United States. He took his subjects from Genesis and Deuteronomy, which, following the example of the *Biblical Message*, celebrated hope and forgiveness more than ever, through *The Twelve Tribes of Israel* at Hadassah or *The Tree of Life* in Sarrebourg.

At the same time, Chagall continued to paint and engrave: the ceiling of the Paris Opéra (1964), the set and costume designs for *The Magic Flute* (1965), lithographs for *The Circus* published by Tériade (1967), tapestries for the Knesset in Jerusalem (1969), the *Four Seasons* mosaic in Chicago (1972), etchings for *The Psalms* (1980).... However, for the artist nearing the end of his life, his spiritual needs had to come first. He re-read the Old Testament and, in numerous preparatory sketches for his stained-glass windows, he assembled collages made of paper or scraps of material. Each of his windows had to respond

Sketches for stained-glass windows (above). Left: *The Angel with the Candlestick* for the baptistery at Assy (1956–7). Above: fabric collage for the window in the chapel at Sarrebourg (1976).

‚When I was engraving the Bible, I went to Israel and I discovered both light and earth, matter. In Metz, for my first windows, there was the stone. In Jerusalem (Hadassah), everything was new, but here I have my talisman. Once they are all together, it will be like a crown.'

to sacred architectonic, plastic, spiritual and historic requirements. He never renounced his quest for the Eternal. It became his greatest work.

On 28 March 1985 Marc Chagall, the last patriarch of 20th-century art, the prophet of the great book of painting, died peacefully at the age of ninety-seven in Saint-Paul-de-Vence, where he is buried.

Like the setting sun, his genius shone brightest at the end. 'Everything can change, in life and in art, if we pronounce the word love without shame.... It is in this that true art lies.'

Above: Chagall and his grandson Piet Meyer at Saint-Paul-de-Vence. Below: *Orpheus* (1959). Overleaf: *Don Quixote* (1974).

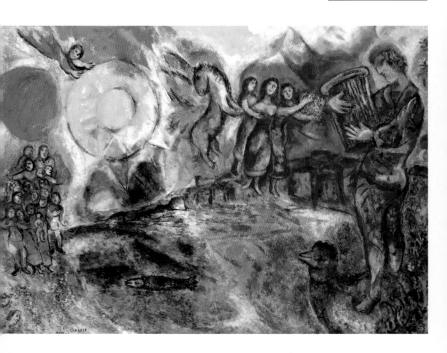

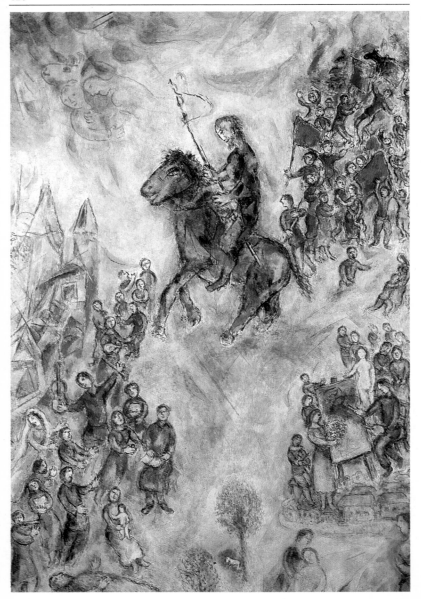

DOCUMENTS

'Chagall is familiar with the spring and the rain.
He treats the sun as an equal. He rejects nothing.
He has, obviously, painted all that interests him,
from horses in flames to the wide-eyed spirit. He is
true to himself in joy and in sadness. Or rather in
that extreme happiness that is well aware of
sadness and hardship.'

Jean Paulhan, 1957

Bella and Marc

In their own words and style, Marc Chagall in My Life *and Bella in* Burning Lights, *followed by* First Encounter, *both evoked their Jewish roots and their growing love for each other. Marc later said of Bella: 'She wrote as she lived, as she loved.... Her words and phrases were a wash of colour over a canvas.'*

Bella and Marc Chagall during the years of the Russian Revolution.

On the Bridge

To us, our bridge is paradise.

From cramped low-ceilinged dwellings, we escape towards the bridge, to gaze up at the sky. In the narrow streets, the sky is hidden.

Churches, roofs pointing upwards. And there, under the bridge, flows the river. Between water and sky, the air becomes clearer.

The breeze bears the scent of flowers. Opposite, on the tall bank, stretches the large town park. During the day, the bridge, which leads from one part of the town to the other, is crowded. While you wander through the streets at leisure, on the bridge, you hurry along. The water and the wind carry you. A coolness rises up through the wooden slats. You feel no desire to return to the banks, into the paved streets.

In the evening, the air condenses into a light ash grey veil. The pillars fade into the water; then the wooden bridge stands out, all white. The river becomes blurred – changing from blue to iron grey. Deep hollows, furrows of a ploughed field, cross it. The water flows, murmurs. Occasionally, a wave breaks – the river roars. I sense that a crowd is following me, but I see no one. I hear nothing. Suddenly, a hat springs up before my eyes.

'Good evening! It's me! Don't be afraid.' A hand greets me.

Once again, that boy. How did he see me? And I am all alone.... I wish I could cry out. But who can I call? I no longer have a voice. Could the bridge have started to rock? My legs tremble. Where has he appeared from? He will think I have been looking for him.

Like someone who is guilty, I remain silent. Why can I no longer be left alone on the bridge in peace? He is following

me, lying in wait for me everywhere.

'What are you afraid of? Are you taking a walk? I am as well. Come, let's walk together!'

He talked to me as if he saw me every day. He is not shy. His voice is calm, confident. His hand, warm, gentle, has become less strange. He no longer seems to be making fun of me.... I look at him. Some of his curls escape from beneath his hat. They swell, fly about, try to escape in the wind. His eyes look straight into mine. I lower my gaze.

'Come on, let's go down by the water, walk there. It's beautiful. Don't be frightened. I know the river bank. I live down there!'

I glance at the steep bank of the river. His house is there. In the darkness, I search for a light, an inhabited dwelling. It is there that he lives....

I feel the need to be at home. My legs no longer obey me. He's the guide. I walk with him. He is not as strange as I thought. He is beside me, a peasant as solid as if he drew steel from the river.

Down the steep steps that descend from the bridge we tumble, as if into a ditch. The bridge remains suspended in the air. The river glistens like a serpent. Nearby, the small low houses sleep.

Is that where he lives? Neither he nor his sisters need to go for a walk on the bridge. The river comes to them, to their door.

Perhaps, because he lives here, he can stay upright on his legs?

He slides, with the river, he floats.

'Let's go and sit over there, there are some tree stumps.'

On the river bank, it is as though he is at home. He knows every log. He can even see in the dark. We knock against piles of logs, long and round. Since we are perched there, we collapse on to them.

'Do you think we are going to fall in the water?'

To him, the river is just a sheet of water. He is not afraid of it. The water murmurs. I say nothing. The water speaks for me. I would like to be able to admit that the gloomy river did not frighten me. I, too, love to walk in the night....

Now, what is going on at our house? Such a long time has passed since I went out. The shop is closed. My parents, my brothers are at the dinner table, eating.

'Where is Bella?' Mother looks around. She swallows a mouthful and thinks.... Can she imagine that I am sitting here on these tree trunks, in the dark, beside the river, and not even with my friends! A young man, unknown, at my side.... Mother would no longer be able to swallow anything, she shakes her head, I see her eyes cloud over, she scolds me, argues....

A wave breaks at my feet. The log rolls beneath me, I nearly fall.

'What is wrong? Why don't you say anything? Is it true that they call you the "Queen of Silence"?' And I thought that I had told him everything!

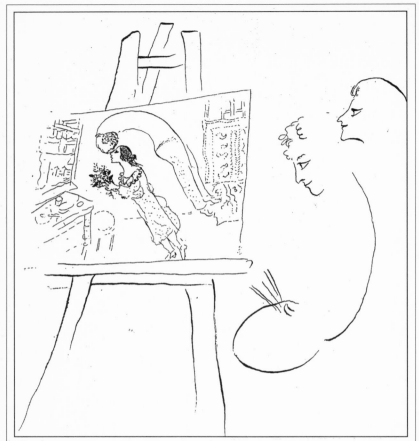

The Birthday

Remember, we were sitting on a summer's evening, above the river, not far from the bridge. Everything around us is in bloom.

The bench is at the top of the steep bank. Below, the river gently drowses, just about to doze off.

At our feet, flowers and bushes emerge from the tall grass quivering along the slope.

Our bench is small, narrow. Our heads lean towards the river, contemplating it.

We are sitting, in silence.
Why speak?
We watch the sun which sets towards us....

'Tell me, how old are you?' I suddenly asked you. 'When were you born, do you know?'

You look at me, flabbergasted.

'Do you really want to know. I often ask myself that. My father told me that in order to exempt my brother David from his military service, he added two years to my age. Anyhow, one cannot deceive the good Lord, and as for lying to an official, the God the Everlasting will forgive him. Provided that David does not have to go into the army.'

'So when were you born then?'

'If you like, we can work it out. I am the oldest. Niouta is the oldest of my sisters. Not long ago, one evening at table, I heard my mother say to my father:

' "Hatché, why don't you see about Hanke?"

'That's what we call our Niouta. "I have to do everything. Must she still wait long? With God's blessing she will soon be seventeen. Go and see the matchmaker, his house is on your way."

'So, if Niouta is seventeen, I must be nineteen at most.'

'When is your birthday? Do you know?'

'Why must you know everything? It'll make you old....'

'Everything? Only when you were born.'

'Who knows? Only mother! And, with so many children, mother has certainly forgotten. But when my sisters argue with me, she always shouts: "You're crazy, you, born in the month of Tammouz...." '

All the stars that have come rushing to listen to your story burst out laughing with us.

"Do you know what I think? You are going to say that I am stupid. It could be that you came into the world in the year that your father has registered you. But you were so afraid of it that it has taken you several years to remember...."

'Do you really think so?'

A shadow passes over you. The sky darkens at the same moment.

'Can't you see that I am joking?'

I hardly dare to smile.

'You're not angry?'

As for me, in the end, I can no longer remember how I came to find out the date of your birthday.

On that day, in the morning, I ran to the outskirts of town to gather a big bunch of flowers. I can still remember how I grazed my hands while trying to pick some tall blue flowers from the top of a hedge.

A dog began to bark. By the skin of my teeth I saved myself, without dropping the flowers. How beautiful they were! I hurried to pick others, straight from the fields, with grasses and roots, so that you could smell the land better. And once I got home, I gathered together all my coloured shawls, my silk scarves. I even seized my decorative bed-cover and, in the kitchen, a girdle cake, some pieces of fried fish, those you liked so much. Wearing my best clothes, laden like a mule, I set out on the path to your house. Don't go thinking it was easy to carry all that stuff....

On the thresholds of their shops, the shopkeepers were taking a breath of air. Each woman knew me, knew where I was going. They winked at each other.

'Where is that crazy girl running to with all those parcels?'

'Isn't she running away from home – may God preserve it – to meet her handsome young man? With young girls nowadays you can expect anything!'

It is lucky that you live on the other side of the river. One can take a short cut, come out at the bridge, cross it, and once on the bank, I am free.

The small houses beside the water have their windows closed. The housewives protect themselves from the

sun. They are busy in their kitchens, which face away from the river. I can breathe at last. Pure sky. Coolness of the river. The water flows, so do I, the sky grabs me again. It dives lower and lower, envelops my shoulders, helps me to run.

That summer, you had a room of your own. Do you remember? Slightly apart from your parents' house, a room rented from a policeman. His little white house, with red shutters, just like the white hat with the red border he wore in summer, was at the corner of the street. There was a long fence enclosing a large garden. With a church in the middle.

You no doubt thought that the policeman and the Holy Church would protect you from everything, including yourself. Isn't that right?

I knocked at the shutter that you often left half-open, even during the day. To filter the light or so as not to be seen from the street?

You came to open the door yourself. Your landlord was not supposed to see me – my visits were too frequent – and even less so, laden with parcels. I wait. The policeman's door is not so easy to open. It is barred from the inside. It takes you a while to unbolt it.

'What is it?' You quickly let me come in and open your eyes wide. 'Where have you come from?'

'Do you think you can only come from the station with parcels? Guess, what day is it?'

'Ask me an easier question. I never know what day it is.'

'No…that isn't what I mean….' Today is your birthday!'

You stand there with your mouth open. If I had told you that the tsar had just arrived in our village, you could not have been more surprised.

'How do you know?'

I quickly unpack my brightly

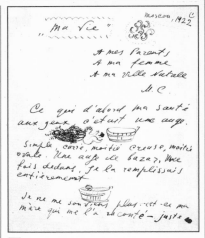

First page of the manuscript of *Ma Vie*.

coloured shawls and hang them on the wall. I spread one on the table, I put my bed-cover on your bunk. And you…you turn round and rummage among your canvases. You bring one out, you put up the easel.

'Don't move, stay where you are….'

I still have the bouquet in my hands. I want to put the flowers in water, or they will wilt. But I soon forget. You have thrown yourself into a canvas which trembles in your hands. You plunge your brushes into the paint. Red, blue, white, black, the colours splash out. You surround me with a torrent of colours. Suddenly you lift me from the ground; you make a leap as if the room were too small. You stretch up to the ceiling. You turn your face towards me, you make me turn mine….

I hear your voice, soft and melodious. This music, I hear it even in your eyes; and in unison, we both rise up above the room and begin to fly. We want to leave

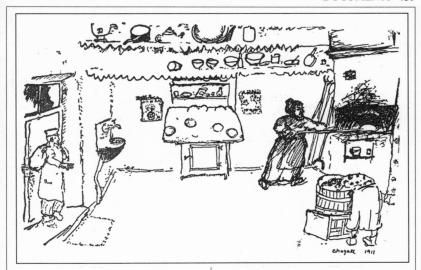

through the window. Outside the sky is calling us. The walls adorned with shawls spin round and round and make us dizzy. Fields of flowers, houses, roofs, courtyards, churches spread out below us....

'Do you like my painting?' Suddenly you are back on the ground again. You look at your canvas, you look at me. First you step back from your easel, then you go up to it again.

'Is there still much to do? Couldn't I just leave it like this? Tell me, where does more work need to be done?'

You are talking to yourself. You wait and you are frightened of what I am about to say to you.

'Oh! It's beautiful. It is beautiful how you have started to fly.... We'll call it *The Birthday*.'

You calm down.

'Will you come back tomorrow? I'll paint another picture.... We'll fly away....'

Bella Chagall, *Première Rencontre*, 1973

'I wish to be a painter'

One fine day (but all days are fine), while my mother was putting the bread into the oven, I went up to her as she held the scoop and, taking her by her floury elbow, said:

'Mamma...I wish to be a painter. It's no good, I can't be a clerk or a book-keeper now. I'm sick of that. It's not for nothing that I had a feeling something was going to happen.

'Look, Mamma, am I a man like other men?

'What am I fit for?

'I wish to be a painter. Save me, Mamma. Come with me. Come on, come on! There's a place in town; if I'm admitted, and if I finish the course, I'll be a complete artist by the time I leave. I should be so happy!'

'What? A painter? You're mad. Let me put my bread in the oven; don't get in my way. My bread's there.'

'Mother, I can't go on. Come!'

'Let me alone.'

In the end, it is decided. We'll go to M. Penne's [Pen's]. And if he sees that I have talent, then we shall think about it. But if not....

(I shall be a painter all the same, I thought to myself, but on my own.)

It's clear my fate is in M. Penne's hands, at least in the eyes of my mother, the head of the household. My father gave me five roubles, the monthly fee for the lessons, but he tossed them into the courtyard, and I had to run out for them.

I had discovered Penne from the platform of a tram that ran downhill towards Cathedral Square, when I was suddenly dazzled by a white inscription on a blue background: 'Penne's School of Painting.'

'Ah!' I thought, 'what a clever town our Witebsk [Vitebsk] is!'

I immediately decided to make the acquaintance of the master.

That sign was actually only a big blue placard of sheet metal, exactly like the ones you can see on shop fronts everywhere.

As a matter of fact, small visiting cards and small door plates were useless in our town. No one paid any attention to them.

'Gourevitch Bakery and Confectionery.'

'Tobacco, All Brands.'

'Fruit and Groceries.'

'Warsaw Tailor.'

'Paris Fashions.'

'Penne the Painter's School of Painting and Design.'

It's all business.

But the last sign seemed to come from another world.

Its blue is like the blue of the sky.

And it sways in the sun and the rain.

After rolling up my tattered sketches, I set out, trembling and anxious, for Penne's studio, accompanied by my mother.

Even as I climbed his stairs I was intoxicated, overwhelmed by the smell of the paints and the paintings. Portraits on every side. The governor's wife. The governor of the town himself. Mr L...and Mrs L...Baron K...with the Baroness, and many others. Did I know them?

A studio crammed with pictures from floor to ceiling. Stacks and rolls of paper are heaped on the floor too. Only the ceiling is clear.

On the ceiling, cobwebs and absolute freedom.

Here and there stand Greek plaster heads, arms, legs, ornaments, white objects, covered with dust.

I feel instinctively that this artist's method is not mine.

I don't know what mine is. I haven't time to think about it.

The vitality of the figures surprises me.

Is it possible?

As I climb the stairs I touch noses, cheeks.

The master is not at home.

I shall say nothing of my mother's expression and her feelings on finding herself in an artist's studio for the first time.

Her eyes darted into every corner, she glanced at the canvases two or three times.

Suddenly she swings round to me, and almost imploringly, but in a firm clear voice, she says: 'Well, my son...You can see for yourself; you'll never be able to do this kind of thing. Let's go home.'

'Wait, Mamma!'

For my part, I have already decided that I will never do this kind of thing. Am I obliged to?

That's another question. But what? I don't know.

We wait for the master. He must decide my fate.

My God! If he's in a bad mood, he'll dismiss me with 'That's no good.'

(Everything is possible – be prepared, with or without Mamma!)

No one in the studio. But someone is moving about in the other room. One of Penne's pupils, no doubt.

We go in. He hardly notices us.

'Good morning.'

'Good morning, if you like.'

He is sitting astride a chair, painting a study. I like that.

Mamma immediately asks him a question.

'Please tell me, Mr S.... What's this painting business like? Any good?'

'Ah well...it's not like shopkeeping or selling, to me.'

Naturally, one couldn't expect a less cynical or less banal reply.

It was enough to convince my mother that she was right, and to instil a few drops of bitterness into me, stammering child.

But here is the dear master.

I would be lacking in talent if I could not describe him for you.

It does not matter that he is short.
It only makes his profile more friendly.

The tails of his jacket hang in points down to his legs.

They float to the left, and to the right, up and down, and at the same time his watch-chain follows them.

His blond, pointed beard wags, expressing now melancholy, now a compliment, now a greeting.

We step forward. He bows casually. (One only bows carefully to the governor of the town or to the rich.)

'What can I do for you?'

'Well, I don't really know...he wants to be a painter.... He must be mad! Please look at his drawings.... If he has any talent, then it would be worth taking lessons, but otherwise....

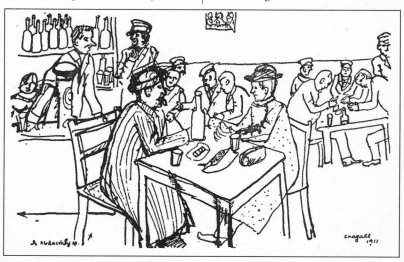

Let's go home, my son.'

Penne did not bat an eyelid.

(You devil, I thought, give us a sign!)

He flicks mechanically through my copies of *Niwa* and mutters:

'Yes…he has some ability.…'

Oh! You…I thought to myself in turn.

My mother hardly understood any better, that's certain.

But for me, that was enough.

At all events, I got some five-rouble pieces from my father and took lessons for nearly two months in Penne's school in Witebsk.…

'In Paris, I thought I had found everything…'

Only the great distance that separates Paris from my native town prevented me from going back home immediately or at least after a week, or a month.

I even wanted to invent a holiday of some kind, just as an excuse to go home.

It was the Louvre that put an end to all this wavering.

When I walked round the Veronese room and the rooms where the Manets, Delacroix, and the Courbets are, I wanted nothing more.

In my imagination, Russia took the form of a paper balloon hanging from a parachute. The deflated bulb of the balloon sagged, cooled off, and collapsed slowly as the years went by.

That's how Russian art appeared to me, or something like it.

Indeed, whenever I happened to think about Russian art or talk about it, I had the same disturbing, mixed feelings, full of bitterness and resentment.

It was as if Russian art had been condemned by fate to follow in the wake of the West.

If Russian painters were condemned to be the pupils of the West, they were,

Chagall photographed around 1910.

I think, rather wayward pupils, by their very nature. The best Russian realist shocks when compared with the realism of Courbet.

The most authentic Russian impressionism is puzzling when it is compared with Monet and Pissarro.

Here, in the Louvre, before the canvases of Manet, Millet, and the others, I understood why my alliance with Russia and Russian art had not worked. Why my very language is foreign to them.

Why no one has faith in me. Why the artistic circles ignore me.

Why, in Russia, I'm only the fifth wheel of the coach.

And why everything I do seems outlandish to them, and everything they do seems futile to me.

I can say no more.

I love Russia.

In Paris, I thought I had found every-

thing, particularly the skills of the craft.

I saw proof of it everywhere, in the museums and in the exhibitions.

Perhaps the East had got lost in my soul; or perhaps the dog bite had reacted on my mind.

But it was not only within the profession that I looked for the meaning of art.

It was as though the gods stood before me.

I no longer cared to think of the neo-classicism of David or Ingres, the romanticism of Delacroix, and the reconstruction of early drawings of the followers of Cézanne and Cubism.

I had the feeling we are still only skimming over the surface of matter, that we are afraid of plunging into chaos, of breaking up the familiar ground under our feet and turning it over.

The very first day after my arrival, I went to the Salon des Indépendants.

The friend who went with me had warned me that it would be impossible to see the whole exhibition in a single day. As far as he was concerned, he came out exhausted every time he visited it. Pitying him from the bottom of my heart and following my own method, I raced through all the first rooms as if a flood were following me and made straight for the central rooms.

In this way I saved my energy.

I made my way to the very heart of the French painting of 1910.

I attached myself to it.

No academy could have given me all I discovered by getting my teeth into the exhibitions, the shop windows, and the museums of Paris.

Beginning with the market – where, for lack of money, I bought only a piece of a long cucumber – the workman in his blue overalls, the most ardent followers of Cubism, everything showed a definite feeling for proportion, clarity, an accurate sense of form, of a more painterly kind of painting, even in the canvases of second-rate artists.

I don't know whether anyone has been able to form a clearer idea than I of the almost insurmountable difference between French painting and that of other countries before 1914. It seems to me that people abroad had very little idea of it.

As for me, I have never stopped thinking of it.

It is not a question of the degree of natural talent in an individual or a people.

Different forces were involved, largely organic or psycho-physical forces that create a predisposition towards either music, painting, literature, or sleep.

After living for some time in a studio in the Impasse du Maine, I moved into another studio more in keeping with my means, in 'La Ruche' ('The Hive').

That was the name given to a hundred-odd ateliers surrounded by a small garden, close to the Vaugirard slaughterhouses. These ateliers were occupied by artistic Bohemians from all over the world.

While an offended model sobbed in the Russian ateliers; the Italian studios rang with songs and the sound of guitars, the Jewish ones with discussions, I was alone in my studio in front of my oil lamp. A studio crammed with pictures, with canvases that were not really canvases, but my tablecloths, sheets, and night-shirts torn into pieces.

Two or three o'clock in the morning. The sky is blue. Dawn is breaking. Down there, a little way off, they slaughtered cattle, cows bellowed, and I painted them.

I used to sit up like that all night

long. It's already a week since the studio was cleaned out. Frames, eggshells, empty two-sou soup tins lie about higgledy-piggledy.

My lamp burned, and I with it.

It would burn until its brightness turned to a glare in the blue of morning.

It was then I climbed up to my garret. I ought to have gone down into the street and bought hot rolls on credit, but I went to bed. Later the cleaner came; I wasn't quite sure whether she came to tidy the studio (is it absolutely necessary? At least, don't touch my table!) or whether they wanted to come up and join me.

On the shelves, reproductions of El Greco and Cézanne lay next to the remains of the herring I had cut in two, the head for the first day, the tail for the next, and, thank God, a few crusts of bread....

'Neither Imperial Russia nor Soviet Russia needs me.'

The Narkompross [the Ministry of Public Education, in the Soviet Republic] invites me to teach in the children's colony known as the 'Third International', and also in the colony in Malachowka [Malakhovka].

These colonies consisted of some fifty children, all orphans, cared for by clever teachers who dreamed of applying the most advanced teaching methods.

Those children were the most unhappy of orphans.

All of them had lately been thrown out on to the street, whipped by thieves, terrified by the flash of the dagger that cut their parents' throats. Deafened by the whistling of bullets and the crash of broken windows, they could still hear the last prayers of their fathers and mothers ringing in their ears. They had

seen their father's beard savagely ripped off, their sisters disembowelled, hastily raped.

Ragged, shivering with cold and hunger, they roamed the towns, hung on to the buffers of trains until they were finally taken in to children's homes – a few thousand among so many others.

And here they are before me.

They lived in several different country houses, only coming together for their lessons.

In winter, their little houses were buried in snow, and the wind, raising clouds of snowflakes, whistled and sang in the chimneys.

The children were busy doing their housework, taking turns to prepare their meals, baking their bread, chopping and carrying their firewood, washing and mending.

They held meetings like men, deliberated, and passed judgment on one another, even on their teachers, and sang the International in chorus, with gestures and smiles.

I taught those poor little things art.

Barefoot, lightly clad, each shouted louder than the other, and cries of 'Comrade Chagall!...' rang out on all sides.

Only their eyes could not or would not smile.

I loved them. They drew pictures. They flung themselves at paints like wild beasts at meat.

One of those boys seemed to be in a perpetual frenzy of creation. He painted, wrote music and verses.

Another constructed his work quietly, like an engineer.

Some of them went in for abstract art, and verged on Cimabue and the art of stained-glass windows.

I continued to delight in their drawings, their inspired stammerings,

until the moment I had to leave them.

What has become of you, my dears?

When I remember you, my heart aches.

They had given me an empty little wooden house so that I should be nearer the colony at Malachowka. However, it had a garret where we could live....

That house still harboured the smell of its refugee owners, the suffocating atmosphere of contagious diseases. Medicine bottles, the filth of domestic animals lay about everywhere....

I am waiting patiently in the anteroom of the Narkompross until the head of the office deigns to see me.

I want, if possible, to get them to set a price for the murals I did for the theatre.

If they won't put them in the 'first category' – which is easily managed by artists less adept than I – at least let them give me the minimum.

But the manager smiles.

'Yes...yes...you understand,' he stammers, 'the estimate...the signatures, the seals.... Lunatcharsky. Come back tomorrow.'

That went on for two years.

I got...pneumonia. Granowsky smiled too.

What more could I do?

My God! Granted, you did give me talent, at least so they say. But why didn't you give me an impressive face, so that people would fear me and respect me? If I were stout, for example, majestically tall, with long legs, and a square head, then people would be overawed by me – that's the way of the world.

But my face is too mild. My voice has no ring to it.

I am in despair.

I trail about the streets of Moscow. As I pass the Kremlin, I cast a furtive glance through the huge gates.

Trotsky gets out of his car; he is tall, his nose bluish-red. He strides boldly across the threshold and goes towards his apartment in the Kremlin.

An idea occurs to me: 'Suppose I were to call on Demyan Bedny, the poet, who also lives in the Kremlin, and served on the Military Committee with me during the war?'

I'll enlist his aid, and Lunatcharsky's for permission to return to Paris.

I've had enough of being a teacher, a director.

I want to paint my pictures.

All my pre-war canvases are still in Berlin and Paris where my studio awaits me, full of sketches and unfinished pictures.

My good friend the poet Rubiner wrote from Germany:

'Are you alive? They say you were killed in the war. Do you know you are famous here? Your pictures have launched Expressionism. They're fetching very good prices. Don't count on the money Walden owes you, all the same. He won't pay you, he maintains the glory is good enough.'

Too bad.

I would rather think of my parents, of Rembrandt, my mother, Cézanne, my grandfather, my wife.

I would have gone to Holland, to the south of Italy, to Provence, and, stripping off my clothes, I would have said:

'You see, my friends, I've come back to you. I'm unhappy here. The only thing I want is to paint pictures, and something more.'

Neither Imperial Russia nor Soviet Russia needs me.

I am a mystery, a stranger, to them. I'm certain Rembrandt loves me.

Marc Chagall, *My Life*, translated by Dorothy Williams, 1965

Chagall in poetry

Chagall had poetry in his veins, expressing it as colourfully with the pen as with the brush. Poets were the first to pay him homage: he was immortalized in verse by Cendrars, his faithful friend; by Apollinaire; by Eluard, who drew up an inventory verging on the surreal, and by Frénaud, who loved religious pomp...

Like a Barbarian (1930–5)

There where the huddled houses throng
There where the path to the cemetery
 rises
There where the swollen river flows
There I dreamt of my life

At night, an angel flies in the sky
A flash of lightning white on the roofs
For me it prophesies a long, long path
It will cast my name above the houses

My people, it is for you that I have sung
Who knows if this song will please you
A voice issues from my lungs
Full of sorrow and fatigue

It is in your name that I paint
Flowers, forests, people and houses
Like a barbarian I colour your
 countenance
Night and day I bless you.

<div align="right">Marc Chagall
Poèmes, 1975</div>

Si mon soleil brillait dans la nuit
Quand je dors tout couvert de couleurs
Dans un lit de tableaux
Quand ton pied dans ma bouche
M'étouffe, me torture!

Je me réveille dans le désespoir
D'une journée nouvelle, de mes désirs
Pas encore dessinés
Pas encore frottés de couleurs
Je cours là-haut

Je marche sur ton âme
Sur ton ventre
Je bois le restant de tes années
J'ai avalé ta lune
Le rêve de ton innocence
Pour devenir ton ange
Et te protéger à nouveau

Marc Chagall

My Land (1946)

Only that land is mine
That lies in my soul.
As a native, with no documents
I enter that land.

It sees my sorrow
And loneliness,
Puts me to sleep
And covers me with a fragrance-stone.

Gardens are blooming inside me,
My flowers I invented,
My own streets –
But there are no houses.
They have been destroyed since my
 childhood
Their inhabitants stray in the air,
Seek a dwelling,
They live in my soul.

That's why I smile sometimes
When the sun barely glimmers,
Or I cry
Like a light rain at night.

There was a time
When I had two heads,
When both faces were covered with a
 film of love—
And evaporated like the scent of roses.

Now I imagine
That even when I walk back
I walk forward –
Toward high gates,
Beyond them, walls are strewn about,
Where worn out thunders sleep,
And broken lightning—

Marc Chagall, *Poèmes,* translated from
the original Yiddish by Benjamin and
Barbara Harshav in *Marc Chagall and
the Jewish Theater,* 1992

Rotsoge (c. 1915)

To the painter Chagall

Your scarlet face your biplane
 convertible into hydroplane
Your round house where a smoked
 herring swims
I must have a key to eyelids
It's a good thing we have seen Mr
 Panado
And we are easy on that score
What do you want my old pal M.D.
90 or 324 a man in the air a calf who
 gazes out of the belly of its mother
I looked a long while along the roads
So many eyes are closed at the roadside
The wind sets the willow groves weeping
Open open open open open
Look but look now
The old man is bathing his feet in the
 basin
Una volta ho inteso say Ach du lieber
 Gott
And I began to cry reminiscing over our
 childhoods
And you show me a dreadful purple
This little painting where there is a cart
 which reminded me of the day
A day made out of pieces of mauves
 yellows blues greens and reds
When I left for the country with a
 charming chimney holding its bitch
 in leash
I had a reed pipe which I would not
 have traded for a French Marshal's
 baton
There aren't any more of them I haven't
 my little reed pipe any more
The chimney smokes far away from me
 Russian cigarettes
Its bitch barks against the lilacs
And the vigil lamp is burned out
On the dress petals have fallen
Two gold rings near some sandals
Kindle in the sun

While your hair is like the trolley cable
Across Europe arrayed in little many-
 coloured fires.

Guillaume Apollinaire
translated in *Chagall: A Retrospective*,
edited by Jacob Baal-Teshuva, 1995

Portrait (1913)

He's asleep
He wakes up
Suddenly, he paints
He takes a church and paints with a
 church
He takes a cow and paints with a cow
With a sardine
With heads, hands, knives
He paints with a bull's pizzle
He paints with all the dirty passions of a
 little Jewish town
With all the exacerbated sexuality of the
 Russian provinces
For France
Without sensuality
He paints with his thighs
He has eyes in his ass
And it's suddenly your portrait
It's you reader
It's me
It's him

It's his fiancée
It's the corner grocer
The milkmaid
The midwife
There are tubs of blood
They wash the newborn in
Skies of madness
Mouths of modernity
The Tower as corkscrew
Hands
The Christ
The Christ is him
He spent his childhood on the Cross
He commits suicide every day
Suddenly, he is not painting
He was awake
Now he's asleep
He's strangled by his own tie
Chagall is astonished to still be alive

Blaise Cendrars
Complete Poems,
translated by Ron Padgett, 1992

Studio (1913)

The Beehive
Stairways, doors, stairways
And his door opens like a newspaper
Covered with visiting cards
Then it closes.
Disorder, total disorder
Photographs of Léger, photographs of
 Tobeen, which you don't see
And on the back
On the back
Frantic works
Sketches, drawings, frantic works
And paintings...
Empty bottles
'We guarantee the absolute purity of our
 tomato sauce'
says a label
The window is an almanac
When the gigantic cranes of lightning
 empty the booming barges of
 the sky and dump buckets of thunder
Out fall

Pell-mell

Cossacks Christ a shattered sun
Roofs
Sleepwalkers goats
A lycanthrope
Pétrus Borel
Madness winter
A genius split like a peach
Lautréamont
Chagall
Poor kid next to my wife
Morose delectation
The shoes are down at heel
An old jar full of chocolate
A lamp that's split in two
And my drunkenness when I go see him
Empty bottles
Bottles
Zina
(We've talked about her a lot)
Chagall
Chagall
In the graduations of light
 Blaise Cendrars, *Complete Poems*,
 translated by Ron Padgett, 1992

To Marc Chagall (1950)

Donkey or cow cock or horse
Even the shell of a violin
A singing man a single bird
Agile dancing man with woman

A couple drenched in its own spring

Gold of grass lead of sky
Separated by blue flames
A little health a little dew
Rainbowed blood and tolling heart

A couple the first gleam of day

Catacombed beneath the snow
A vine in opulence outlines
A countenance with lips of moon
That has not ever slept at night.

Paul Eluard
The Dour Desire to Endure,
translated by Stephen Spender and
Frances Cornford, 1950

Marc Chagall's song

The little red rooster will fly very high
if animality loves the angel

The clear laugh of the sheep can be
 heard
through the clock
when the naked clouds rise
beyond the houses
carrying us with the fiancée
We are on our way and our hearts start
 to beat
in colours of green and purple
Do not be afraid This is not a game
If my head is not there it is dallying
 where it has to
It will arrive on the way down to rejoin
 us
up high perhaps
with the fish that stretch out
Do not be afraid seeing that I am with
 my fiancée
it does not really matter that I appear
 outside myself
when I scour the country
to gather the pregnant beasts
for my stall of full-blooded tenderness

For everyone the goodness of the
 devil
is set in motion by the virtue of the
 spring
The universe half opens when I make it
 strut
A thousand blinks in the eyes of a
 peacock
The crazy space which I make appear
in order to elevate the desirable holy
 beauty.

André Frénaud

'Not a dream; but life'

Chagall spoke on many occasions about the sources of his inspiration. The following statements are taken from a lecture he gave in Chicago in February 1958, entitled Art and Life, *in which the artist stated his beliefs.*

I do not choose; it is life itself which choses the natural technique for me.

What importance do you attach to line, to colour? With what aim?

I don't know.

Imitation of other painters? What is Chagall searching for there?

What I am searching for: work as the meaning of life.

Do you just happen to paint a dream that seems to occur suddenly, or is it a question of an elaborated and constructed vision? Have you ever tried to retranscribe a dream?

Not a dream; but life.

Do you believe in work or inspiration?

We are what we are, right from the moment we come into the world.

What role does Surrealism play in your oeuvre? Have you entirely rejected its influence?

I did so-called Surrealism from 1908. Surrealism appeared as an ISM from 1925 onwards.

Is composition of prime importance in your paintings?

In paintings, everything is necessary.

Are your dreams important in the realization of your canvases?

I don't have dreams.

In front of a landscape, are you more sensitive to the light or to the lines?

Before every landscape, I am moved; but I am also similarly moved before man and before certain events in life.

An intellectual asked me the following questions:

What is the relationship between Art and Life?…

Of course, I can enjoy many things which are being accomplished in our life and in our present culture. And we cannot enumerate here all that is talked about in the newspapers.… If I was a sociologist, I could, eventually, throw light on that state of things using

material motivations. Sometimes, one withdraws into oneself with sadness to avoid hearing, and to avoid seeing. And one thinks of such and such a prophet lying on the sand and prophesying for himself and for the passers-by who were ready to listen to him.

He also asked me: Have the natural sciences taught me anything useful for my art?...

Art, in the last resort, is not something consciously scientific. An artist without his instinct is like a pendulum.

He also asked me: Is religious faith necessary to an artist?...

Art, in general, is an act of faith. But sacred is the art created above interests, such as glory, fame or any other material consideration.

We don't exactly know what kind of men Cimabue, Giotto, Masaccio, Rembrandt were. But very fortunate is the hour of our life when, facing them, we are moved to tears.

For me, even Watteau is religious, with his flowers, his lovers, his bushes. If his paintings were placed in a religious temple, instead of being in the Louvre, the emotion felt would be even greater.

In the course of these last ten years, I have worked a great deal. Joy came to me in the form of books being edited, and among them, the Bible.

I have chosen to paint: to me it has been as indispensable as food. Painting appeared to me like a window through which I would fly away to another world. Speaking of that, you will excuse me for recalling the biblical image of Moses who, in spite of his stammering, was haunted by God so that he would do his duty. In the same way, we are all, in spite of our stammering, pursued by someone so that *we* will perform *our* duty.

I see again the poor house of my youth where, it seems to me, on the door and in the sky, until night, shone also a burning bush. But I was then only in the house of my parents. Around me there were, haunting me, the bustle of the household, my parents' worries, my life when I felt so lonely and saddened by my father's tiredness (my father fed and raised with difficulty his nine children).... Haunted by all that, I left by another way which is, maybe, the same way as my father's who, on looking then at my drawings, thought that they were a continuation of the wall.

Since that time, I have travelled a great deal. I have seen many countries. I have taken different roads looking for colours, looking for light. I have thrown myself into a certain observation of ideas, of dreams. But along that road, I have come up against wars, revolutions, and all that goes with them.... But I also have met exceptional people; their creations, their charm, and their contact have often quietened me down, reassured and convinced me to carry on.

More clearly, more precisely, with the years, I have come to feel the relative righteousness of our ways, and the ridiculousness of anything that is not produced with one's own blood, and one's own soul, which is not saturated by love.

Everything is liable to change in life and in Art and everything will be transformed when we pronounce, unconstrained, this word 'Love' – a word which indeed is wrapped in an envelope of romanticism (but we do not have, for the time being, another word). In it lies the true Art: from it comes my technique, my religion; the old and the new religion which has come to us from far distant times.

Translated in *Chagall: A Retrospective*, edited by Jacob Baal-Teshuva, 1995

The artist and the Bible

'If we had nothing of Chagall but his Bible, he would be for us a great modern artist, but also a surprising anomaly in the art of an age which otherwise seems so remote from the content and attitude of this work.'

Meyer Schapiro
Verve, 1956

Chagall with Father Couturier and Jacques Maritain at Orgeval in 1950.

'In Art as well as life, anything is possible provided there is Love'

I have been fascinated by the Bible ever since my earliest childhood. I have always thought of it as the most extraordinary source of poetic inspiration imaginable. That is what I care about most, both in life and in art. The Bible is a synonym for Nature and that is what I have tried to convey.

In the course of my life I have often had the feeling that I was someone other than myself, that I was born somewhere between heaven and earth, so to speak; the world has always struck me as being one vast desert where my soul wanders like a lighted torch. What these paintings are all about is that old dream of mine, and it has been my wish that they remain within these walls, so that they may bring people a sense of peace, spirituality and religion, and give meaning to their lives.

To my mind, these paintings express a dream that belongs not to a single tribe but to all mankind. They came about as the result of my encounter with the French publisher Ambroise Vollard, and of my journey to the Middle East. I want them to remain in France, because that is the place where I feel I was reborn for the second time.

It is not for me to comment on them. Works of art must speak for themselves. There has been much debate about the criterion by which colour should be judged, and what school to put it in. But a grasp of colour is innate. It has nothing to do with the manner or form in which it is applied. Nor does it depend on one's mastery of technique. It is alien to all schools. All that remains of the historical schools is the odd artist blessed with an instinctive understanding of colour. The

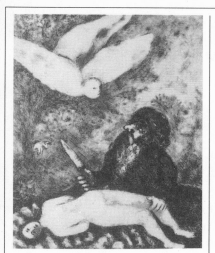

Abraham Preparing to Sacrifice his Son in accordance with God's Command, plate 10 of *The Bible*.

schools themselves are largely forgotten.

After all, what inspires paintings, as well as colour, is Love. Paintings are but the reflection of our inner world, which means that technique is secondary. Colour, not technique, conveys a painter's character and message.

As life is an inexorable course towards death, we must enliven it with our own colours of love and hope. Such love gives life its social cohesion and religion its essence. As far as I am concerned, perfection in Art and in life has its source in the Bible, and exercises in the mechanics of the merely rational are fruitless.

Perhaps young and old will come to this House in quest of an ideal of brotherhood and love, such as that expressed in my colours and my images. Perhaps also words of love, of the love I feel towards all, will be spoken here. Perhaps even there will be no more enmity, so that young and old will then be able to build their world of love and cast it in a new colour, the way mothers bring forth children in suffering and love.

People of all persuasions will be free to come here and bask in this dream of mine, far removed from the frenzy and evil of the modern world.

It is my wish that works of art and documents of high spiritual quality may be displayed here, and that true poetry and music from all over the world may be heard within these walls.

An impossible dream?

In Art as well as life, anything is possible provided there is Love.

Marc Chagall,
The Biblical Message in the guide to the Musée National Message Biblique Marc Chagall, translated by Mary Delahaye, 1997

The poetry of the Bible for a Christian

I would reproach myself if I appeared to solicit in some way or another an art that is only religious, so to speak, despite itself. It is so nevertheless, at least according to the most unformulated aspiration. And I am allowed to point out that precisely because he has neither sought nor intended anything in this way, the plastic world of Chagall's Bible, so deeply and painfully terrestrial, as yet incomplete, and as if groping in a sacred night, unwittingly testifies to the figurative value of the great lyricism of Israel. The more this world is Jewish, and embroiled in the laborious speculations of the three great Patriarchs who are the image of the three divine Beings, the less I can tell which evangelical call silently resounds there....

Jacques Maritain,
in *Cahiers d'Art*, no. 114, 1934

The painter of the Promised Land

To discern in Chagall's undertaking a deliberate search for the unusual would be very much mistaken. While these works astonish, they never seek, in line with the canons of Surrealist painting, to surprise or disconcert. Here there is no conceited enigma, no wicked Sphinx demanding from us an immediate, impossible response.... No brutality in the guise of the wonderful; nothing but a voice.... So it is in this Christ on the cross resting on a clock which bears an enormous, pensive fish into mid-air. He is not presenting one of those countless rebus of the unconscious, more assiduous than difficult, which some find so delightful. Beyond the opulent tables, laden with fruit, flowers, candlesticks – our life in the lavishness of its appearance – is, as though invoked, but without imposing itself, the image of an ambiguous mystery, joy and suffering together, totally strange and yet familiar to everyone....

Chagall, it seems to me, proceeds rather like the Biblical story of Genesis, which brings things into being, side by side, and stacks them in tiers in time – but which also binds them together lovingly, and at a single stroke, through the unifying phrase 'and God saw that it was good'.

Chagall is not the painter of the Diaspora, but of the Promised – and already divided – Land. It is as though in his work there is a joyful confusion of the tangible, an interpenetration of the orders, of the immense and the minute, from the terrestrial to the sidereal, from memory to imagination. He lays before us a sort of polymorphous mystery of the creation in which, with cheerful lack of concern, all the protagonists play all the roles at once with no superior hierarchy attempting to restrict them to their narrow identity. And if God in person happens to speak, he wears neither the robes of the Judge, nor even those of the Creator…he is caught in the whirl of angels and human beings, with their violins, their reefer jackets, their caps. Similar to the image that the disciples of the *poverello* of Assisi would have made of it, he is, by our sides, this bearded Christ, mujik, fiddler or ruffian. And the great circle of the sky is like an arm coiled above all the heads....

In a world in which the gods are silent, Chagall continues to make his art an act of piety. This piety, however, is based on nothing more than a little nostalgia; it pays homage to living man, to a 'light coming from elsewhere' which fills him and illuminates him but which cannot be separated from him.

It is, I believe, with a similar faith that we must welcome his paintings. Any attempt to interpret them, to relate them to a pattern of logic, would be in the end to disregard both their specificity as works of art and their transcendental dimension.

It is necessary to read Chagall literally, like the bulky books of our childhood – not so as to unveil the mystery, but, page by page, to participate in it. This painting is the moving profile of people in the immemorial form of fable. And fable calls for a circular plot, a repetitive lyricism, a liturgy. Thus one dreams for Chagall of a time in which frescoes, once again, will be inscribed on the walls they group together. No doubt, it would not be the great cathedral church with its unitarian message, already lofty, too self-confident on the dust of the town, which would be best suited to these humane lessons of hope,

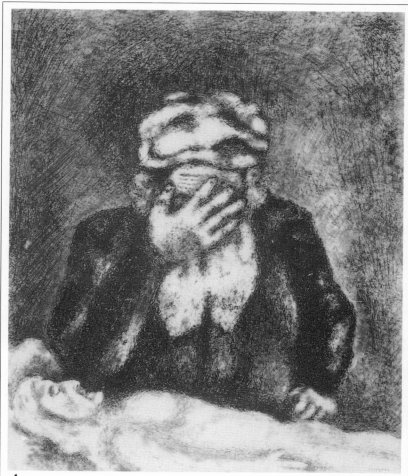

Abraham Mourning Sarah, plate 11 of *The Bible*.

but the rows of white chapels, clinging to the hillside, like those monasteries of the East, distributed gently across the land by the chalky paths for the footsteps of the faithful, prophets and beggars.

Claude Esteban, *Derrière le Miroir*, no. 182, December 1969

Monumental Chagall

Chagall was the inspired revivalist of the art of the stained-glass window in the West. Charles Marq, who oversaw his stained-glass projects, describes the painter's 'monumental' path, from glass to mosaic, from mosaic to tapestry.

Chagall with Brigitte and Charles Marq in the studio at Reims.

Chagall is the prey of art and in a very particular way he submits to the universality of the spirit. If he speaks of love, is it not as testimony of this world without boundaries or contours, which has neither top nor bottom, left nor right, simply obedient to the colour that overflows in it. This 'colour-light', of which the painter has spoken since his first encounter with Paris, manifests itself in a forceful way in his monumental oeuvre. Anxious to find in his subject the tradition that the image of time surrenders, he immediately goes beyond it to reveal the image of his soul. If he pays attention to the function and character of a site – the church, the temple, the synagogue, the opera house, the concert or conference hall, it is to bind them in a single vision of universal love. Likewise, respecting the architecture in which the work is to be situated, he creates it as a marriage of love and not of convenience, exalting the life of the space in which it is situated rather than being influenced by the spirit of geometry.

During the twenty years that have witnessed the birth of his monumental oeuvre Chagall has of course experienced one by one and sometimes simultaneously places devoted to prayer in all its forms, to poetry, music and dance, as well as to understanding between men. This happens everywhere life leads him, as a man and as an artist.

It was in 1954 that Chagall, who had conceived the project back in 1948, began to paint the seventeen great canvases of his *Biblical Message* that are at the heart of this museum and this exhibition. From this vast fresco, as in the engravings of *The Bible*, spring the figures of the Patriarchs and the Prophets, who evolved into the stained-glass windows and tapestries.

Indeed the project is so vast and fills Chagall's mind to such an extent that, shortly after beginning it, he became involved from 1957 in a long series of other works in which he was to reiterate with a new tone his meaning of life, with its suffering and its sacrifices, with its illuminations and its prophetic visions, with its songs and its dances. But this time it was a question of a

commission, an imperative order, 'fate', as Chagall said, which bound him to people, society, a building, a history. Fate that called for the total mobilization of his vital strength and his inner life in order to go beyond, to submit to and to speak of the freedom of people in the creation.

Firstly, in 1957, there was the commission for the Metz windows. Here he used glass for the first time and worked face to face with light and radiant colour. His feeling for the Gothic space was of such depth and vitality that his line seems to spring from the blazing of the forms and his colour to resuscitate the ancient colour. In the vertical lancet windows stand the Patriarchs and the Prophets springing from their cobalt and madder grounds, while David sings his harmonies seated at the crossing of the coloured poem of blues and reds, purples and yellows. Entirely new to him, this material provided him with new strength, and was, as he himself says, the 'talisman'

that, when one knows how to love it, will reveal its soul.

In 1959, before the first window in Metz was even completed, Chagall received the commission for the *Jerusalem Windows*, which he accepted with enthusiasm. It presented a new problem, because traditionally the synagogue does not allow the human figure to be represented. So, leaving in the West his lofty biblical figures, Chagall conceived in the land of the Bible and in the light of the Orient the cycle of the twelve tribes of Israel, developing all the richness of the coloured prism in an inventiveness of forms that transforms the whole into pure universal poetry. One only has to look at the collection of maquettes and sketches exhibited here to appreciate the scope and careful reflection with which Chagall conceived a monumental work.

Commissions continued to flood in. Chagall's choices were always made out of deep love for humanity and the truth of his inner message. The commission

Chagall working in the Gobelin workshops on the Knesset tapestries.

for the ceiling of the Paris Opéra in 1963 marked for him the natural as well as troubling conclusion to his innate love for music and dance. Above all, it was an opportunity for him to render homage and express his gratitude to those who had brought him into the world of art and who daily, through their music, inspired and strengthened his work as a painter. This huge project, to which he devoted all his energy in 1964 and which was donated to France, did not prevent him from testifying at the same time to the sacred value of *Peace* in the window he executed for the United Nations in New York. In this, surrounded by all his peoples, Isaiah reveals his vision of the future when love will reign on earth. In the same year he completed the *Paradise* window for Metz Cathedral, a golden song of the Creation of human love, while he began to weave three large *Tapestries for the Knesset* in Jerusalem, which he had designed shortly before. Here, in the midst of the crowd spreading across the three parts of the triptych, comprising the hardships of *Exodus*, the joy of the *Entry into Jerusalem* and the hope of *Isaiah's Vision*, rise the great figures of this people, Moses, David and the Prophet.

In 1965 Chagall once again responded to the call of music, when he agreed to execute the two great mural paintings in the entrance hall of the Metropolitan Opera in New York. For this beautiful space opening out on to the square of the Lincoln Center he composed two great symphonies in red and yellow, as ethereal and resonant as the music whose sources he transformed into poetry and whose triumph he enhanced. Sublime pages of passion and nobility, where the figure of the poet with the double face of Orpheus and David springing from *The Sources of*

Music flies at the summit of inspiration, echoed by the Angel, messenger of the divine breath who sounds *The Triumph of Music* in the midst of the glory of reds.

Nothing seemed capable of halting his generosity and his creative genius. After stained glass, he turned his attention to mosaic, as if delighted to submit his inspiration to the play of another kind of light. When he had raised between heaven and people a wall of glass, the generator of inner light, it was with fresh delight that he watched the wall of stone rise in mid-air, receiving its light from the infinitely changing sky. After the mosaic for the library of the Fondation Maeght in 1965, the floor of the Knesset eventually ended up by enclosing the great hall of tapestries. Then, from 1966 to 1967, after completing a marvellous winter garden in Paris and a wall for his house in Saint-Paul, he designed the great mosaic for the hall of the Faculty of Law in Nice, which was completed in 1968. This *Message of Ulysses* is on the scale of an epic poem, exalting the magnificence of the Greek hero, through which Chagall also testifies to his admiration for wisdom placed at the service of people, through all the hardships of experience. He had barely completed the work begun ten years earlier in Metz, crowning the triforium of the north transept with stained-glass windows flooded with light in which his bouquets and flowers soar in the blueness, before he was dreaming of a new cycle commissioned for the *Fraumünster* in Zurich. Excited by the site and the opportunity it presented to create a space coloured entirely by his efforts, Chagall set to work, completing it in the course of 1970. In the tall, narrow Romanesque lancet windows

of the choir the painter expresses the
soaring force of the spirit, lifting up the
prophet Elijah, the messengers of Jacob's
Dream and those of celestial Jerusalem.
It is finally all the Prophets, the Angels,
the celestial City, the Virgin and Christ
who bear the body and the spirit in their
levitation. The colour itself soars in
powerful patches on monochrome
backgrounds of red and blue, green
and yellow glass, creating at the heart
of this space the resulting colour which
seems to me to be the inner colour of
the painter.

During this time, however, the
building for the 'Message Biblique'
museum has taken shape and is ready to
receive the great paintings completed in
1967, which the painter and his wife
Valentina have donated to France.
Here, once again, Chagall's genius
creates new opportunities for perfecting
and completing the work. In 1972 he
created the *Tapestry* for the entrance to
the museum, the mosaic of the *Prophet
Elijah* and the windows of the *Creation*,
which illuminate the concert hall. Deep
sentiment and meaning emanate from
the works conceived for this location.
Mystically wedded to the beautiful light
of the building, the mosaic receives the
fire from the sky like Elijah in his chariot
and reflects in the mirror of water the
circle of the zodiac, rhythm of cosmic
time, while the windows through the
midnight blue of the first days and the
blue of the rest on the seventh day reveal
to us the creative act of the painter from
its conception to its completion. Chagall
continues the creation of this spiritual
building both in time and space. When
this exhibition opens, the stained-glass
windows in Reims will only just have
been placed in the cathedral. There,
issuing from the blue background of the
Gothic building, spring the images of

First stages of the work at the Gobelin
studios for the ceiling panels of the Paris
Opéra.

Abraham and Christ. Shrouded in
mystery and receiving the radiance of
vision, the figures of the Old and New
Testament cast their light and shadow
on the geneology of the Kings
of Judah and of the Kings of France.

Chagall's monumental work, which is
made up of the same ingredients as his
painting, is a marvellous continuation of
it. The entire oeuvre, which is devoid of

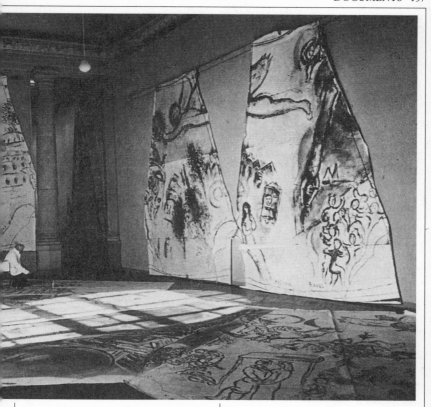

any sentiment or decorative concept, is the image of his soul, of a heart and spirit full of the desire to communicate love and to occupy with his creation a place made for all. In so doing, it seems to me, Chagall realizes the dream that many this century have entertained, never achieving it with this unique depth and profound reality, a dream that came to the artist because it is that of all peoples: to view art as the messenger of the inexpressible, to build in the heart of the city his poem of mystery and love.

Charles Marq
Catalogue to the exhibition
'Marc Chagall, Maquettes et esquisses pour l'oeuvre monumental' at the Musée National Message Biblique Marc Chagall, Nice, 1974

The Chagallian aesthetic

Beneath its apparent diversity, where does the unity of Chagall's painting lie?

Chagall in Vence in 1957.

The admirable Chagall

Painting! A man has spent his life painting. And when I say his life, you must understand what I mean. Everything else is gesticulation. Painting is his life. What does he paint? Fruits, flowers, a king entering a city? Everything that is explainable is something other than life, that is, from what he understands by life. His life is painting. Inexplicable. Painting or talking perhaps; he sees like the rest of us hear. Subjects are painted onto the canvas like simulated sentences. Connected words. After all, the words make a sentence, there is nothing to understand; is it this way with music? Then why is it not so with painting? Let us start from the beginning. How does one begin to write about this unfinished world, this strange, unfamiliar country, this weightless land where there is nothing to differentiate a man from a bird, where the donkey lives in the sky and everything is a circus, and where we walk so well on our heads. No explanation is needed if colour is used to emphasize a rooster on a flutist's arm and a naked woman is drawn in the shadow of his neck while in the distance the sun and moon bathe the village in gold. We are constantly before the clock. The second hand shows the path. The spectacle is *given*: men and women surrounded by visions of brutal beasts, characters from a travelling theatre company, a meaningless sabbath in Brocken, childhood obsessions, wandering souls, gymnasts from a topsy turvy world, jugglers accompanied by an invisible violin. People's fantasies in a world so full of lovers that it is hard to choose one. Without doubt, no painter has ever flooded my eyes with so much light, with nights that are so divine.

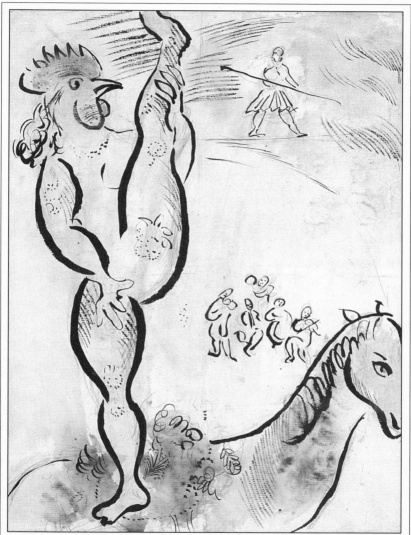

There is a Chagallian dialectic for which *The Midsummer Night's Dream* is the only precedent I know. No need to have rags adorn the actors who wear anything from sequins to feathers, and bouquets are somehow thickets that are

compared to dancers. The older the painter became, the more he took a pagan pleasure in shavings of colours. The mirage is not at the end of a desert but in a shimmering vision mingling human beings and animals; nor do we know in which day-dream the hand lovingly cuts up shadow and light and feels through the fingers a scattering of green and orange. The painter sometimes appears, palette in hand, at the bottom of the canvas, with an animal-like expression on his face reminiscent of Bottom. The whole world seems to be in front of him like the model of an imaginary parade where far-away visions and dreams become reality and the unconscious becomes the conscious. Any everywhere, almost everywhere, it is the kingdom of touch, the caressing world of hands, mostly opened – who else has ever painted like this?

An ox walks by in the distance so slowly that the violin dies out and every embrace depends on the silence of love constantly being reinvented, as if it is always the first time, the same wonder felt at adolescence.

Wonder here hardly depends on understanding because everything I recognize increases rather than diminishes the sense of mystery. Peasants, clowns or lovers for one night. And the villages off in the distance that can also be Notre-Dame, the Eiffel Tower, or the Opera. Even Paris is the countryside, with its lights that could be lilacs. In the old days painters used to leave students and artisans free to add details to the secondary characters, thereby changing the perspective of their major works: these were all *postiches*.

Chagall in Vence with David.

Chagall always rejects any hasty interpretation of his paintings that may make them non-provocative.

One character starts running through the streets on his hands, another takes off through the sky, head cast downwards, face turned away; try to get a sensible and coherent story, at least so that a mythology can be defined. The painter tends to contradict the general composition through the detail and even upsets the balance of what the painting seems to say – for example, when animals are coupled with human beings, to which I dare you to attach any symbolic meaning or value. Time does not change this work that covers more

than eighty years. On the contrary, nowadays, the logic of arbitrariness predominates, a challenge hurled at age, a mockery of time and of its power. Some will certainly say that some of Chagall's paintings contradict my observations and will insist on the coherence of the subject matter, particularly because in the great biblical works the painter seems to comply with the 'story' as it is told, to respect and even illustrate it. But what does this prove, except that the painter is extremely versatile. Besides one mythology does not preclude another.

Certain paintings, having looked at them for so many years in a particular way, no longer strike us as either strange or irrational. Their *irreducible* quality eludes us. But this is precisely wherein lies their greatness, their poetry. Since a Chagall scene is hardly reminiscent of everyday life, it is impossible to give a common meaning to the individual elements. For this painter, the rigour of composition resides in his freedom. It is my belief that Chagall is dominated by the pleasure he gets from his painting, from the hegemony of colours, rather than by what he is trying to represent. I like him most of all when he seems to get lost or unravelled in apparent disparity. Also, he seems to play in a strange kind of kaleidoscopic way that

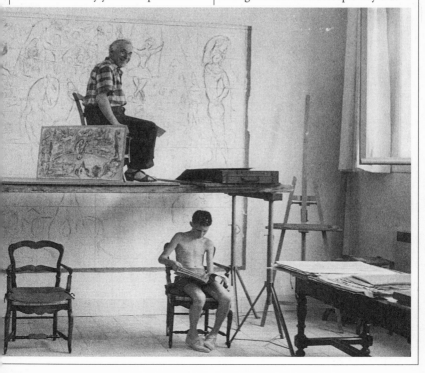

always destroys the geometric balance just as the work of art is about to be finished.

With Chagall there is a bestiary to assemble, and if at times parents, horses and birds are all there, variations in their morphology are to be expected. I would like to take the example of a recent painting in which on a deep blue night the moon is black and the ground once again bears a Belorussian village; someone is sitting under a raging sky and, like a thunderbolt, lightning falls like a scarf on his shoulder...try and describe this! When it is really the indescribable, two birds, a naked child, a female figure laterally traced in white against a dark background, a pony, and this face lighting up the top of the canvas – does it belong to the body striped in brown, black, green and fresh blood? And below on the left, cast in light, is the pinkish head of a horse with a green body whose blue foot rests on the paleness of a moon-like face (or is it a stone?) while the other foot and its fine ankle seems to belong to the mysterious pregnant woman in the sky. Look at it! You will probably not see what I am observing, and bless your eyes if they see something else. I only wish to warn you against any tendency to impose on these nocturnal paintings or even on those bathed in sunlight an arbitrary mythology. Do not wake the painter up. He is dreaming, and dreams are sacred. Secret things. He will have dreamt his painting and his life. The world is his night just as he has made his day.

Louis Aragon,
preface to the catalogue of the exhibition held in Budapest, April 1972
Translated in *Chagall: A Retrospective*, edited by Jacob Baal-Teshuva, 1995

High 'chemistry'

Painting dominates all that Chagall undertakes, from sculpture to lithography, from ceramics to stained glass. In painting the marriage between all the plastic elements the painter refers to as his 'chemistry' is continually renewed. But his other means of expression are no less essential. Thus, in the painter's hands, lithography becomes that 'great river flowing towards distant and beautiful banks' of which he has recently spoken. It provides his painting with wings for its flight throughout the world, a flight similar to the one that has always carried it through interior spaces. In it, we find an 'echo' of the original chemistry, a resonance at once distant and close, and the quivering of the colour in the painting, increasingly intense since the war, finds perfect expression there. The lithographs allow us to follow this extraordinary ascent step by step. It appears initially as a liberation from black, executed either in brush or pen, to which colour is added. But observe how that colour has for a while now played a more active part and reflects as completely as the black the diabolic and tender mobility that characterizes the slow conflagration and sharp whisper of the colour in the painting. Thus on the sheet of paper the increasingly passionate marks and lines create that miraculous, vibrant and dense space that opens before us with the power of memory and the dazzle of a promise. It seems to me that Chagall's final lithographs possess a quality never before equalled and thus belong entirely to that high 'chemistry' of colour that reigns in his oeuvre.

Franz Meyer,
unpublished article

An imagination that unfolds *ad infinitum*

In Chagall, this poetry of metamorphosis is accompanied by things that are constant, just as the handkerchief and rabbit are constant in the case of the conjuror. I am referring to those objects, animals and characters that are always the same and that continually reappear in canvas after canvas. So modest are they in number that an entire inventory can be drawn up in a few lines. These constant characters are: the pedlar, the acrobat, the angel, the musician – and the couple, continually and always the couple, sweet and discreet in their eroticism: the fiancée, even when naked, is certainly a virgin and the man is always clothed. Then come the animals: the horse or the donkey, the ox, the cow, the cock, the fish. Lastly, the objects: the clock, the violin, the ladder, the flowers, the Eiffel Tower and the humble wooden houses. Fifteen, perhaps twenty or so figurines, no more, which he arranges on the canvas as a child would do, a little one here, a little one there, without gravity, without perspective, according to his mood – and humour. It might easily be supposed that, in these compositions, there would be little variety. But one knows that the number of possible combinations of guests around a table increases with their number, to such dizzying proportions that it is hard to believe: while four guests can only be seated in twenty-four different ways, six can already be seated in seven hundred and twenty ways; eight in five thousand four hundred; twelve in sixty-four million.... The possible combinations for placing twenty guests – or twenty figurines – is counted in thousands of millions, without counting, in Chagall's case, the metamorphoses! Were the painter to live for another ten thousand years, he would still be far from exhausting the number of combinations open to him. Hence the impression of constancy before his work, and at the same time, of an imagination that aims to limit itself and that unfolds *ad infinitum.*

Chagall's painting is the remarkable example of a synthesis of two routes. Yes, it is the royal route: where the painter resorts to a certain imitation of things but only in order to give birth to his own world, nothing but his – an independent world which, without having entirely broken with the tangible, the everyday, has only a floating, hazy link with reality – simply in order to proceed with his own 'creation of the world'; and this world from now on exists, not only hanging in the galleries but henceforth in our spirits and in our hearts and without it, were it to disappear, our inner life would feel incomplete, truncated. When it comes down to it, this is where the sign of a 'great painter' lies; from the great artist who, through his grace, allows us to feel – and share – the remarkable dignity of people; of the magician who, with simplicity, because he loves and he dreams, candidly draws us along behind him beyond the cruelty of things and the tyranny of appearances. That is Chagall.

Vercors
in *Derrière le miroir*, no. 235,
October 1979

Jean Leymarie renders homage

One of the prominent figures in French museum circles who has always defended Chagall, Jean Leymarie, the chief curator of the Musée National d'Art Moderne in Paris, organized the important retrospective held at the Grand Palais in Paris in 1969.

Chagall at Les Collines in Vence, about 1959.

It is now sixty years ago since the astonished child from the Russian provinces arrived in the capital of art and discovered, hanging around the street with its passers-by as well as the paintings in the Louvre, 'that astonishing light-freedom' which he still admits, after so much travelling, never to have found elsewhere, and in which he was to bathe, for its comparison and apotheosis, the made-up splendour of his own world....

Chagall's art focuses around the mythical and supernatural world of his childhood, from which adult reason abolishes mystery. Two dominant themes govern his oeuvre, which eventually develops in veritable cycles, that is to say in organically linked groups in which each element is valid in itself as well as in relation to everything that incorporates it, the Circus and the Bible. Raised in a pious family in the heart of those modest Eastern European Jewish communities deeply penetrated by Hassidic mysticism, Chagall has always possessed this intuitive knowledge of the Bible that naturally provides him with access to the holy. To the Jewish people the Bible is the complete historic and transcendental cycle binding the concrete singularity of events and individuals to its superior reality. Chagall's symbolic creation tends to identify itself with this revolving biblical space where nothing is without echo, reflecting and justifying in its course all human experience. Since 1950, he has composed a monumental suite of seventeen paintings arranged thematically, his *Biblical Message*, presented to the state in 1967 to be housed in the 'place of meditation' that is being built for it on the hills above Nice. It is striking to note that, while twelve of them refer to a specific episode

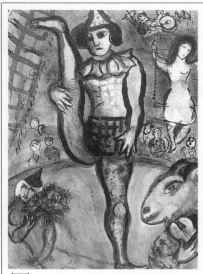

The Acrobat, 1955.

In our era, Chagall is undoubtedly the only artist of calibre to take up once again an interrupted tradition and to draw from the Bible so broadly and continuously. On the other hand, all the great contemporary painters have shown their passion for the ritual of the circus, in which they discern a metaphor for the world and the reflection of their own life. Without being able to give reasons for it, Chagall senses the close relationship, also discernible in Rouault, between religious subjects and those of the circus. Watching a circus performance at his side is as revealing as following a bullfight next to Picasso. In Russia, the circus enjoyed a lively and long-standing popularity.... The circus ring is the magic circle that defies gravity and encourages total freedom of movement and emotion within the most rigid discipline. Circus scenes first appear in Chagall's work in 1913, increasing in 1927 and in 1937 and, since 1956, have occurred continuously, like *The Bible* series, as major works such as *Large Circus* or *Travellers* still show in 1968.

from Genesis or Exodus, the Song of Songs benefits from five successive versions....

Like many Jewish artists or thinkers, Chagall is also totally overwhelmed by the solitary figure of Christ assuming, beyond all the dogma, the noblest humanity; dying, his arms spread on the cross, in a supreme act of love and sacrifice, he opens himself to the plenitude of redeemed reality. In his own words, Christ was to Chagall 'the man with the most profound understanding of Life, a figure central to the mystery of Life'. First appearing in 1909, crystallized in the mysterious masterpiece *Golgotha* in 1912, the theme of the Crucifixion, which combined for him the symbols of the two Testaments, embodied from 1938 and starting with *White Crucifixion*, the tragedy of the world.

The animals that take part in the circus performance occupy a symptomatic position in Chagall's mythology. The cow and the sheep appear above all before 1914, the donkey and the horse after 1924, and since 1928, the cock and the fish have predominated, linked to each other by their ritual value and their antagonistic poles, sun and moon, water and fire. Chagall believed in the reconciliation of wild beasts and all the creatures in the Messianic kingdom prophesied by Isaiah, and also restored to life the world before the Fall, 'primitive and maternal Nature' which Mircéa Eliade mentions in this connection, when people lived in harmony with the animals and understood their language.

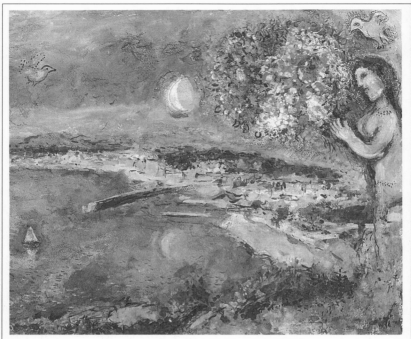

Untitled, 1978 (above). Opposite: Chagall working in Reims on the windows for the Hadassah University Medical Centre in Jerusalem in 1961.

Flowers also have their language, which is one of love and heavenly hymns. 'I simply opened the window of my room and the blue air, love and flowers came in,' Chagall said, speaking of his engagement. Right from the earliest days in Russia, he has always painted flowers, incarnations of colour and messengers of love. But, by his own confession, their essence was only fully revealed to him under the Mediterranean sun, firstly in the south of France, in spring 1926, then later in Greece, in 1952 and 1954. Initially intermediaries for landscape, set in the window – another recurrent motif – between the foreground space and the space in the distance, they eventually came to signify the landscape itself and, joining with lovers and floating figures, weave the entire space with their radiant emanations and the soft atmosphere that they engender....

Chagall's creativity rests aesthetically on what he describes as the *chemistry* of colour, on the magical gift of animating matter and of transmuting it into light. Resounding and penetrating at the same time, gems and moss, receptive to sharp or subtle contrasts, submissive to the inflections of the soul, to leaps of the imagination, this fluid colour can also be adopted in vast stretches on a dominant tonality, black and white included, and

infinite nuances. Its transparency and its flash lent to its sublimation in the technique of stained glass, which truly fashions light and manifests the essence of the divine. Like ceramics, stained glass is an art of transubstantiation through fire, its material no longer being the earth but the heavens, from whence its mystical destination. In painting, Chagall explains, the artist tackles two artificial and rebellious elements, the canvas and the colours, which he must unite, hence the unequal struggle and the laboured victory. In the case of ceramics, without thwarting it, he precipitates the union of two natural elements, earth and fire. If he acts without submitting to these elementary forces, the result is a decorative or gaping crack. In the case of stained glass, he must humble himself still further in order to harvest the light and reap the blueness, to achieve that airy grace that is the fruit of age and the reward of a pure soul in communion with the world.

Jean Leymarie
in *Hommage à M. Chagall*, 1969

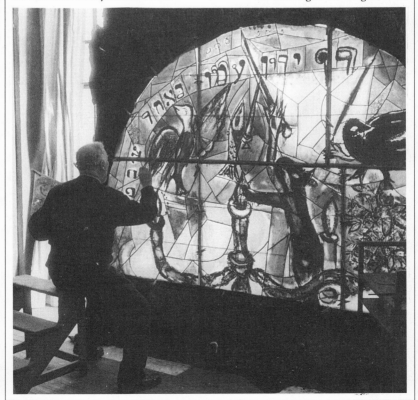

FURTHER READING

SELECT BIBLIOGRAPHY

Cassou, Jean, *Chagall*, trans. Alisa Jaffa, 1965
Chagall, Bella, *Burning Lights*, 1988
—, *First Encounter*, 1983
Chagall, Marc, *My Life*, trans. Dorothy Williams, 1965
Forestier, Sylvie, *Chagall, l'oeuvre monumental, les vitraux*, 1987
—, *Musée National Message Biblique Marc Chagall, Nice, Catalogue des collections*, 1990
Haggard, Virginia, *My Life with Chagall*, 1986
Kamensky, Aleksandr, *Chagall: The Russian Years, 1907–1922*, 1989
Leymarie, Jean, *The Jerusalem Windows*, 1968
Teshuva-Baal, Jacob, (ed.), *Chagall: A Retrospective*, 1995
Werner, Alfred, *Chagall: Watercolours and Gouaches*, 1977

EXHIBITION CATALOGUES

Amishai-Maisels, Ziva, *Chagall in Jerusalem*, Jerusalem Museum of Art, Jerusalem, 1993
Compton, Susan, *Chagall*, Royal Academy of Arts, London, and Philadelphia Museum of Art, 1985
Leymarie, Jean, *Marc Chagall*, Grand Palais, Paris, 1969
Marc Chagall and the Jewish Theater, trans. Benjamin Harshav, The Solomon R. Guggenheim Museum, New York, 1992
Marchesseau, Daniel, *Chagall, les années russes, 1907–1922*, Musée d'Art Moderne de la Ville de Paris, Paris, 1995
Prat, Jean-Louis, *Marc Chagall, rétrospective de l'œuvre peint*, Fondation Maeght, Saint-Paul de Vence, 1984
Provoyeur, Pierre, *Marc Chagall, oeuvres sur papier*, Musée National d'Art Moderne, Paris, 1984

LIST OF ILLUSTRATIONS

DOCUMENTS

INDEX

ACKNOWLEDGMENTS

The author and publishers particularly wish to thank: Meret Meyer for granting them access to the Ida Chagall archives; Bella Meyer Simonds; Michel Brodsky; Sylvie Forestier, Curator of the Musée National Message Biblique Marc Chagall, Nice; Didier Schulmann, Curator at the Musée National d'Art Moderne, Paris; Léonard Gianadda at the Pierre Gianadda Foundation, Martigny; Solange Thierry from *L'Oeil*, Paris; Madame Bidermanas; André Fourquet; Mariane Sarkari.

PHOTO CREDITS

All rights reserved 26b, 70b, 75b, 76, 77, 81a. Angel-Sirot, Paris, 85b. Archives Photo, Paris, 129, 158. Art Institute of Chicago 90, 92. Bibliothèque Nationale de France, Paris, 144. Bildarchiv Preussischer Kulturbesitz, Berlin, 37b, 64c, 65b, 88a. Boymans-van Beuningen Museum, Rotterdam, 80. Ida Chagall archives, 11, 12, 13l, 13r, 14a, 14b, 15al, 15ar, 16a, 16b, 17a, 18b, 19a, 20–1a, 20, 21, 22l, 22r, 23a, 24l, 26a, 28, 29a, 29b, 30b, 31a, 31b, 32b, 33, 34, 35, 36b, 37a, 37c, 38l, 38r, 39a, 39b, 40r, 41a, 42a, 42c, 42b, 43, 44, 45, 46a, 46b, 47l, 47r, 47c, 48–9, 50b, 51a, 51b, 52l, 52r, 52b, 53, 55a, 55b, 56, 57a, 57b, 58–9, 60–1a, 60l, 60r, 61l, 61r, 63, 65al, 65ar, 67a, 67b, 68ar, 68br, 70c, 71l, 71r, 72, 74, 75al, 75ar, 78a, 78b, 79b, 82c, 82b, 91, 93, 94a, 94b, 95b, 96–7a, 96b, 97, 98l, 98r, 99l, 99r, 100, 101, 102, 103a, 103b, 104, 105, 106l, 106r, 106b, 107, 108a, 108–9, 109, 110, 111l, 111ar, 111cr, 111b, 112l, 112r, 113, 114–5, 116, 117, 118a, 118b, 119a, 119c, 119b, 120al, 120ar, 120b, 121al, 121ar, 121b, 124b, 125ar, 126al, 126ar, 127a, 127b, 128, 130, 131, 132, 134, 135, 137, 138, 142, 146, 148, 149, 151, 159, 160–1, 165, 166. Charmet, Jean-Loup, Paris, 18c. Explorer/Peter Willi, 88b. Gallimard/F. Foliot, 23c, 23b, 24r. Gallimard/R. Parry, 81c. Giraudon, front cover, 73, 122, 123, 124–5a. Solomon R. Guggenheim Museum, New York, spine, 30a. Izis, Paris, 1–9, 152, 153, 154, 156–7, 164, 167. Musée National d'Art Moderne, Paris, 15b, 25a, 36a, 40l, 54a, 62, 83, 86–7, 88–9a. Museum of Modern Art, New York, 32a, 82a. Nagoya Museum, Japan, 69. Offentliche Kunstsammlung/Martin Bühler, Basel, 95a. Ostier, André, back cover. Philadelphia Museum of Art 27. Rapho/Silvester, Paris, 118c. Réunion des Musées Nationaux, Paris, 84a. Roger-Viollet, Paris, 17b, 18a, 19b, 25b, 41b, 50a, 54b, 64a, 66, 70a, 79a, 81b, 84b. Stedelijk Museum, Amsterdam, 68l. Tel Aviv Museum of Art 85a.

TEXT CREDITS

Grateful acknowledgment is made for use of material from the following works: (pp. 144, 144–5) Blaise Cendrars, 'Portrait' and 'Studio', *Complete Poems*, translated by Ron Padgett, University of California Press, 1992; copyright © 1992 Ron Padgett, © 1947 Editions Denoel; reprinted by permission of Ron Padgett and University of California Press, USA. (p. 143) Marc Chagall, 'My Land', translated from the original Yiddish by Benjamin and Barbara Harshav in *Marc Chagall and the Jewish Theater*, 1992; reprinted by permission of Benjamin and Barbara Harshav. (pp. 14, 15, 18, 38, 45, 57, 64, 135–41) Marc Chagall, *My Life*, translated by Dorothy Williams, Peter Owen Ltd, London, 1965; reprinted by permission of Peter Owen Ltd, London. (p. 145) Paul Eluard, 'To Marc Chagall', *The Dour Desire to Endure*, translated by Stephen Spender and Frances Cornford, 1950; reprinted by permission of Faber and Faber Ltd, London.

Daniel Marchesseau
was born in Paris in 1947. Chief Curator of the
Cultural Heritage, he has organized numerous
exhibitions both in France and abroad. In 1973,
encouraged by Jacques Lassaigne, he published
several monographs and catalogues, including
*Tanguy, Modigliani, Marie Laurencin, Diego
Giacometti, Calder Intime* (awarded the Vasari Prize
for publications on art in France and published in
English as *The Intimate World of Alexander Calder*)
and *Dubuffet*, prior to organizing the exhibition
'Chagall, les années russes 1907–1922', held at the
Musée d'Art Moderne de la Ville de Paris to mark
the tenth anniversary of the painter's death.

*In memory of Jacques Lassaigne, friend of Marc
Chagall, former director of the Musée d'Art Moderne
de la Ville de Paris, who was as committed to life as
he was to his writing.*

© Gallimard/Paris-Musées, 1995

Works by Marc Chagall © Succession
Chagall-ADAGP 1998

Works by Marc Chagall © DACS
London/ADAGP 1998

English translation © Thames and Hudson Ltd,
London, 1998

Translated by Ruth Taylor

British Library Cataloguing-in-Publication Data

A catalogue record for this book is available
from the British Library

ISBN 0–500–30085–2

Printed and bound in Italy
by Editoriale Libraria, Trieste